101 GREAT THINGS
TO DO WITH YOUR
DIGITAL CAMERA

101 GREAT THINGS TO DO WITH YOUR DIGITAL CAMERA

SIMON JOINSON

D&C
David and Charles

A DAVID & CHARLES BOOK

Copyright © David & Charles Limited 2006

David & Charles is an F+W Publications Inc. company
4700 East Galbraith Road
Cincinnati, OH 45236

First published in the UK in 2006
Reprinted 2006
Text and illustrations copyright © Simon Joinson 2006

A catalogue record for this book is available from the
British Library.

ISBN-13: 978-0-7153-2412-7 paperback
ISBN-10: 0-7153-2412-8 paperback

Printed in China by WKT Company Limited
for David & Charles
Brunel House Newton Abbot Devon

Commissioning Editor Neil Baber
Editor Ame Verso
Project Editor Nicola Hodgson
Designer Simon Joinson
Production Controller Kelly Smith

Visit our website at **www.davidandcharles.co.uk**

David & Charles books are available from all good
bookshops; alternatively you can contact our Orderline
on 0870 9908222 or write to us at FREEPOST EX2 110,
D&C Direct, Newton Abbot, TQ12 4ZZ (no stamp required
UK only); US customers call 800-289-0963 and Canadian
customers call 800-840-5220.

INTRODUCTION

There are lots of books available on how to take pictures, and lots of books on how to use a camera. There are also many books around on the amazing things that you can do to your pictures using advanced image-editing software such as Adobe Photoshop. This book is something a little different, however; it is full of ideas for great things you can do with your digital camera, along with tips on how to get the best pictures. Some of these are purely practical, and many of them are concerned with sharing your pictures with your friends and family. The remainder of the tips, towards the end of the book, are designed to help you take the first steps towards becoming a creative digital photographer.

Above all, this is a book designed to show you how much fun you can have with a simple digital compact camera – most of the 101 tips and ideas do not require any specialist equipment, and all are suitable for the absolute beginner.

Digital cameras and camera phones have transformed the way in which we take pictures. Not only are we free from worries about wasting film, but the screen on the back means we can easily check that we've got the shot we want. And the fact that the photos produced can be easily and inexpensively shared with anyone with access to the Internet opens up whole new worlds of possibilities. Using this book as a starting point, you'll soon find yourself taking more pictures and having more fun with your camera than you ever thought possible.

CONTENTS

CHAPTER ONE:
CAMERA BASICS

CHAPTER TWO:
SHARING PHOTOS

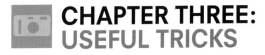

CHAPTER THREE:
USEFUL TRICKS

CHAPTER FOUR:
TIPS FOR BETTER PHOTOS

CHAPTER FIVE:
SOFTWARE PROJECTS

CHAPTER ONE:
CAMERA BASICS

TAKE CONTROL OF YOUR CAMERA'S BASIC CONTROLS AND OPTIONS

Digital cameras are extremely sophisticated tools that are capable of producing great results in widely varying situations. Whether you are shooting into the glare of the midday sun or capturing a city skyline in the dead of night, the automatic exposure and focus systems on modern cameras are generally remarkably reliable.

But there will always be situations where the automatic systems fail, or where you want to override them for creative effect. Here, we'll look at the controls and options that are common to all digital cameras, and how to exploit them to take better pictures. Even if your camera has little or nothing in the way of manual overrides we will show you how to use the white balance, exposure compensation and ISO controls that are common to all models. And even these most basic controls will allow you to overcome most common photographic problems and become a little more creative with your pictures. We're going to start, though, with some of the absolute basics.

Auto

number 01 GET TO KNOW YOUR MENUS

The better you know your camera, the more likely you are to use the many options and settings on offer. For the best results, leaving everything on auto is no good – unless you always shoot in perfect sunshine!

number 02 BUY A BIGGER MEMORY CARD

The key to getting the most from your camera is to experiment, and the key to getting great pictures is to take lots! Buying a large memory card (one with at least 128MB) will mean that you don't need to worry about running out of space when you are out shooting, and will also allow you to use the best quality setting available.

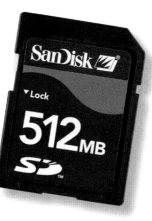

number 03 GET TO GRIPS WITH EXPOSURE MODES

Although all digital cameras are capable of great results in their idiot-proof fully automatic mode, many offer a wide range of automatic and manual exposure modes too. By learning when – and how – to use these modes you can tailor the camera's settings to give perfect results in a wide range of shooting situations, as well as get to grips with some of the more advanced creative effects used by the pros.

Scene modes
Most modern cameras have a selection of scene (or subject) modes that are specially designed for specific types of photography – such as landscapes, portraits, night shots, and sports shots. Using the right mode can greatly improve your pictures, as well as helping you avoid the more common photographic pitfalls.

Manual modes
As you learn more about photography you can start to experiment with manual control of apertures and shutter speeds – essential for the more creative effects that are described later in this book.

number 04 EXTEND YOUR BATTERY LIFE

Although they have become much better, digital cameras are still very power-hungry, and there's no surer way to miss the shot of a lifetime than to run out of power miles from anywhere. Always carry at least one spare set of batteries with you, fully charged, and turn the LCD screen off when not using it.

number 05 GET TO GRIPS WITH SHUTTER SPEEDS

From avoiding blurry pictures to freezing action and shooting at night, mastering shutter speeds and ISO settings ensures that you get the best shot time after time...

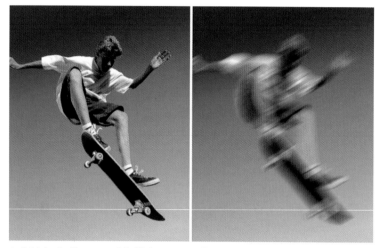

▲ A high shutter speed (left) freezes motion; a slow shutter speed (right) allows the subject – or camera – to move during the exposure, which can result in blurring.

The ability to control the duration of the exposure of a photograph can be used as a powerful creative tool, especially when you are shooting digitally (where depth of field is difficult to alter). Most modern cameras allow shutter 'speeds' (durations) of anything from several seconds to 1/1,000th or even 1/10,000th of a second. Again, just to confuse you, shutter speeds that are a fraction of a second are often shown in the camera's menu without the '1/' part: 1/125th of a second might appear as '125'. So you need to remember that a higher number usually means a shorter exposure. There are several factors involved in choosing a shutter speed; let's look at them individually...

Avoiding camera shake

If the shutter speed is too low, and the camera is not firmly supported you will get camera shake – an overall blurring of the entire frame. There are no set rules here; it depends on everything from the zoom setting in use to the size, shape and weight of the camera, and to the steadiness of your own hands. As a general rule of thumb, you need a shutter speed that is roughly the same as the (35mm-equivalent) lens focal length in use. Thus, a typical 38-115mm-lensed camera will need you to use, as a minimum guideline, 1/40th sec at the wide end and 1/125th sec at the long end of the zoom. Most cameras will display the shutter speed in use on the LCD screen, even when you are shooting in fully automatic mode.

Controlling the amount of light

If you want to set a specific aperture to control depth of field, this will dictate the shutter speed that you choose. Longer shutter speeds let in more light, so are needed for dark scenes.

Capturing motion

High shutter speeds can freeze motion, whereas slow shutter speeds allow subjects to move during the exposure, creating blur within the image. Both of these can be powerful tools for conveying a sense of action within a scene. With a long exposure, it is vital that the camera remains as stationary as possible to avoid camera shake and to try to ensure that the rest of the scene is sharp and unblurred, helping to add to the sense of an object in motion.

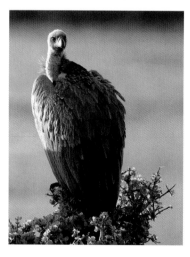

◀ Telephoto shots and action shots need higher shutter speeds.

Virtually all modern cameras can display shutter speeds on-screen, though not all allow you to control them yourself.

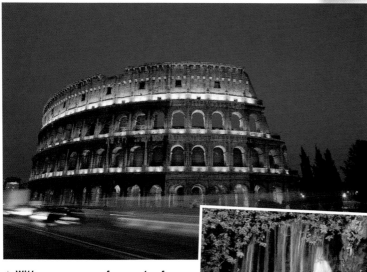

QUICK TIPS

Although there are no hard-and-fast rules, here are some examples of suitable shutter speeds for typical subjects:

✔ Landscapes with a wide lens, handheld: 1/30th sec or higher
✔ Telephoto shots of non-moving subjects: 1/200th sec or higher
✔ Freezing motion (car or running animal moving across frame): 1/500th sec or higher
✔ Freezing motion (car or running animal moving towards you): 1/250th sec or higher
✔ Freezing action with a long lens: 1/1,000th sec or higher
✔ Panning (following motion): 1/10th to 1/30th sec
✔ Blurred water (waterfall etc): 1/2 sec or longer*
✔ Car light trails and fireworks: 1/2 sec or longer*

*these situations need a tripod

▲ With an exposure of a couple of seconds - and a sturdy tripod - you can capture the light trails caused by cars passing during the exposure.

As a general rule, you need a shutter speed of no longer than 1/40th sec at the wide end of your zoom if you want to avoid camera shake, rising to around 1/125th at the long end of a 3x zoom, and 1/300th if you've got a FinePix with a 6x lens and want to handhold the long end of the zoom range. If you go any lower than these settings, you will need to support the camera or the image could come out blurred.

Long exposures

Long exposures are a challenge for any photographer, but as long as you support the camera properly to avoid camera shake, it's not too difficult and the end results can be amazing. Most digital cameras can set exposures of up to one or two seconds in their fully automatic ('program') mode; all you need to do is turn

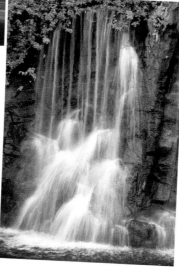

▲ With a long exposure (here it's 1 second) only the moving parts of the scene will be blurred - in this case, the water in the waterfall.

off the automatic flash and the camera will do everything else for you. Many models have scene (or subject) modes specifically designed for shooting in low light without flash, and some even have special long time exposure settings. Roughly speaking (and presuming a sensitivity setting of ISO 100) dusk and dawn scenes

need exposures in the 1/4 to 1 second region, whereas to get an exposure in the deep of night (such as the car trails image shown above), you might need 4 or even 8 seconds. Shooting well-lit night scenes (the neon glow of a busy city, for example) with a higher sensitivity setting might even allow handheld exposures in the 1/25th or 1/15th region, but only if you have a steady hand. Be aware that long exposures tend to exacerbate noise in the image.

number 06

USE FASTER AND MORE ACCURATE AUTOFOCUS

Ever missed a shot because your camera couldn't focus in time? Here's a handful of tips for avoiding problems...

Most of us have experienced focus problems because, no matter how modern or well-specified it is, there are always going to be times when the focus system simply cannot react as quickly as you would like it to - especially in low light or at the long (telephoto) end of the zoom. Fortunately, you can overcome the limitations of the autofocus system by remembering a few simple tricks.

Wider is faster

Virtually all compact cameras focus faster (up to twice as fast), and miss less often the nearer you move to the wide end of the zoom. This is especially important if you are shooting in low light, where the extra brightness and extra depth of field at the widest setting make focus problems rare. For this reason, despite the slightly unflattering effect of shooting portraits using a wide-angle lens, we'd recommend not zooming in too far when trying to snatch quick shots in dimly lit

social situations (such as bars or restaurants). If you are shooting portraits at short distances (say, under 1m/3ft), you will often find that switching the macro mode on speeds up focus and reduces focus errors to virtually nil. This is because the camera looks only for subjects that are close by, and therefore won't accidentally focus on the background.

Manual focus

More advanced Finepix cameras have a manual focus mode, which can get rid of the autofocus delay entirely. If you are shooting anything over a distance of about 4.5m (15ft), you can safely switch to the maximum focus distance (infinity) and rely on depth of field to ensure that everything comes out sharp.

Pre-focus

By far the safest way to ensure you capture the moment you're waiting for is to make use of the focus lock built into all autofocus

cameras for a technique known as pre-focusing. If you half-press the shutter release the camera will focus as normal, but the picture won't be taken until you push the button all the way. If you hold the button half pressed until the right moment there will be virtually no delay before the picture is taken. This technique is ideal for one-chance shots, such as surprise parties, grooms kissing brides and cake cutting. Simply pre-focus on something near the subject and wait for the moment. It's also the only way to capture fast action with most cameras - the half-second or so it takes to focus means that, without pre-focusing, the action is over by the time the picture is taken.

▲ **At the long end of the zoom, focus can be difficult in low light.**

▲ **Pre-focusing (in this case on the ground where the car was due to land) ensures the picture is taken as soon as you press the button.**

▲ **Stick to the wide end of the zoom in low light and you won't miss the vital moment.**

GET TO GRIPS WITH YOUR ISO SETTINGS

number 07

If you have ever wondered what that 'ISO' option was in your camera menu was, then read on...

ISO is a measure of how sensitive your camera's sensor is to light. Put simply, higher ISO settings allow you to take pictures in lower light without needing long exposures, which would result in camera shake.

Digital cameras allow you to do something film never did – to change the ISO setting from shot to shot, according to your needs.

So why don't photographers just use the highest sensitivity setting all the time? Surely that would be a sensible approach to avoiding camera shake in every situation? Unfortunately, this is not the case. There are a couple of very good reasons for having the option to change the ISO setting. The first is versatility; high sensitivity means you need very little light to get the right exposure, meaning creative techniques such as limiting depth of field by using a very wide aperture, or using long exposures to capture motion, would prove difficult. Sometimes you simply don't want the camera to be that sensitive to light!

The second reason concerns image quality. Digital camera sensors are not very sensitive to light, and most have an 'optimum' ISO setting of ISO 80 or even less. The higher ISO setting comes through amplification of the signal, and the more you amplify the more noise you get. This means the camera's processor has

to use noise reduction software to smooth things out. Together, noise and noise reduction have an increasingly detrimental effect on image quality as ISO increases.

Most digital cameras have ISO settings ranging from around 80 to 400, with a few going up to ISO 1600. ISO 200 is twice as sensitive as ISO 100, which in turn is twice as sensitive as ISO 50, and so on. What this means is that if a shot needs a 1/25th second exposure

▼ **Low ISO settings give the best results, and are perfect for bright, sunny days.**

▲ **High ISO settings let you take pictures in low light without a tripod and (left) with telephoto lenses and no camera shake.**

at ISO 50, it will need a 1/50th at ISO 100 and 1/200th at ISO 400. The difference between 1/25th and 1/200th second can be the difference between camera shake and a perfectly sharp picture – which is why the ability to increase ISO is so important!

Choosing ISO
The default setting on most cameras is 'auto ISO', where the camera sets the ISO according to the brightness of the scene. You can, however, change the ISO setting manually, and it is worth learning how to do this so that you, rather than the camera, can make the decision. On bright days when you want the best possible quality, you will usually want to use the lowest ISO setting (in the region of 50 to 80). You can also use low ISO settings at night to avoid noise, but you will need to use a tripod to avoid camera shake. High ISO settings (400 and above) are used for low light shooting without flash, or for capturing fast action where a high shutter speed is essential. Aim to use the lowest possible setting for the best quality.

number **08**

MASTER EXPOSURE COMPENSATION

Even if you never use your camera's more advanced manual features, it pays to learn basic exposure compensation for when things don't go according to plan...

▲ **A large expanse of sky in the scene can cause underexposure of the foreground. Increasing the exposure by +0.6 or even +1.0 EV (Exposure Values) reveals the detail.**

When you press the shutter and take a picture with your digital camera, you don't expect the picture to come out too bright or too dark; modern digital cameras have such advanced metering and exposure systems that it can come as something of a surprise to discover that they are not completely foolproof. But there are times when things go wrong, and the reason for this is simple. No matter how sophisticated the systems that measure the brightness of the scene and decide on the exposure, the camera cannot know *what* you are taking a picture of, and therefore it has to make some assumptions.

There will always be times when the camera gets it wrong, because the scene is too 'non-standard' – and there will be times when you actually want a slightly brighter or darker image than the metering

indicates, for creative reasons. And this is where the Auto Exposure Compensation (AE-C) feature comes into play.

AE Compensation
AE-C allows you to increase (brighten) or decrease (darken) the exposure set by the camera

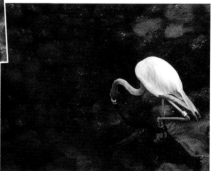

▲ **A small subject that is much brighter or darker than its surroundings will often be incorrectly exposed. Using −0.7 EV correction (right) makes sure the main subject of the scene is no longer burnt out.**

on a shot-by-shot basis, and is a standard feature on all but the most basic models. Usually indicated by a small '+/−' logo, AE-C will either have its own button on the back of the camera or will be offered as an option in the record menu. The amount by which you can alter the exposure is variable, usually in steps of 0.3 EV – EVs are 'Exposure Values', where +1EV is double the exposure and −1EV is half the exposure.

Using AE-C

Now forget all about Exposure Values and remember this; a plus (+) AE-C makes the picture brighter, and a minus (–) AE-C makes the picture darker. Roughly speaking, a +1.0 EV setting will make the image twice as bright, a +2.0 EV four times as bright (and vice versa for minus EV settings). So you can think of AE-C as a variable 'brighter/darker' feature, with + for brighter and – for darker.

So when to use it? In truth, most people use AE-C settings to re-take a shot when a problem has been spotted on-screen. So if you take a picture and the instant review looks too dark or

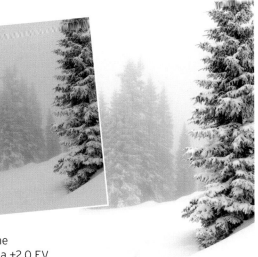

▲ **If your scene has little in the way of shadows or dark tones there is a danger the metering system will underexpose, producing a muddy result. Adding +1.0 EV compensation means the snow looks bright and clean again!**

too bright, you can use AE-C to correct the exposure and try again. This is fine for shots

▼ **If the scene contains a lot of shadows, the camera may overexpose it.**

▼ **A small (–0.3 or –0.7) correction produces a result much closer to how the scene looked in real life.**

QUICK TIPS

✔ Generally, underexposure (too dark) is better than overexposure (too bright) – you cannot fix overexposure in post-processing, whereas you can usually go some way towards rescuing dark shots.

✔ If your camera has a spot-metering option, you can use it to avoid the problems of small subjects or backlighting by measuring the brightness of only the main subject, not the rest of the frame. This does take practice, however!

✔ Some problems can be avoided by the use of AE lock (check your manual – it is usually activated at the same time as focus lock, on half-pressing the shutter).

✔ Backlighting problems can also be overcome by the use of fill-flash.

you can re-take easily (such as landscapes and so on), but less useful if you have been waiting hours for the perfect moment. This is where seasoned photographers can – based on their experience (and familiarity with their camera) – anticipate problems and use exposure compensation *before* they take the shot. This carries the risk of the photographer getting it wrong, so needs to be used with care! One alternative is to use your camera's auto bracketing feature (found on many mid- to high-end cameras), which takes three shots in rapid succession, one at the metered exposure, and one either side (brighter and darker).

EXPOSURE COMPENSATION AND WHEN TO USE IT ...

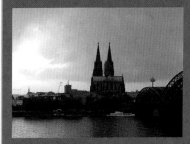

▲ Shooting silhouettes can be tricky – the metering system will try to lighten the scene so you can see some detail in the foreground.

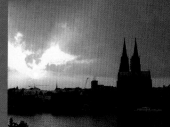

▲ A slight reduction in exposure (–0.7 EV) will bring out the detail in the sunset and render the foreground buildings much darker.

▲ When shooting a subject against a white background you will almost always need to increase the exposure (+AE-C).

▲ Shooting a light subject against a black background will usually require you to make a reduction in exposure (–AE-C).

▲ Backlighting is a common cause of exposure problems. Here, the camera has metered for the background, making the main subject too dark (top). By using a +1.5 AE-C we can brighten up the main subject of the photo.

Typical situations

There are some types of scene that often cause problems for auto-exposure systems.

• **Backlighting:** This is where your subject is framed against a much brighter background. The camera exposes for the background and your main subject comes out too dark. **Solution:** plus (+) exposure compensation.

• **Large expanse of sky:** If the sky is very bright and fills more than half the frame, the camera can be fooled into

underexposing, making anything else in the frame come out too dark. This happens more with hazy, overcast skies than deep blue skies. **Solution:** plus (+) exposure compensation.

• **Small subject:** This is a very similar problem to backlighting. If the main subject is quite small in the frame, and is much brighter or much darker than the rest of the scene, there is a risk of under- or overexposure. **Solution:** if you are shooting a white cat on a black rug you may need a plus (+) compensation; if you are

photographing a black cat on a white rug, use a minus (–) setting.

• **High-key scenes:** If the scene is dominated by pale tones, the auto-exposure system may produce an underexposed result (with whites looking grey). **Solution:** plus (+) exposure compensation.

• **Low-key scenes:** If a scene contains mostly darker tones, the camera can be fooled into overexposing, producing a washed-out result. **Solution:** minus (–) exposure compensation.

number 09

LEARN WHEN TO USE FLASH – AND WHEN NOT TO!

There's nothing guaranteed to rob a picture of atmosphere like on-camera flash, so learn when to turn it off...

Most people leave decisions about the use of flash down to the camera and never give it a second thought - after all, that's what automatic functions are there for isn't it?

Not always. The trouble is that there are times - many times - where the camera doesn't get it right - more specifically, when you would get a much more appealing photo if you turned the flash off. The trouble is that on-camera flash, though undoubtedly useful, has some serious drawbacks. These are due partly to the positioning of the flash itself (very near the lens and pointing straight out) and partly to the lack of power (on-camera flash units are very small, and don't actually put out that much light).

The first of these problems is the worst; on-camera flash produces harsh, unflattering light that makes everyone you photograph look like a 'rabbit caught in the headlights', emphasizes every

▼ Sometimes a little blurriness is far more appealing than the sterile results of using built-in flash.

blemish and wrinkle and causes red-eye. Also, because none of the light in the scene is used to make the picture, using flash in low light robs scenes of any atmosphere, and the relative weakness of the flash means that the background often comes out much too dark. Conversely, there are times, such as when your subject is backlit or in shadow, where you actually want to use flash in bright daylight, something the camera's automatic system will rarely spot.

For all these reasons, you should get into the habit of experimenting with your flash modes - so let's look at three alternatives to auto flash:

Flash on
Use this in daylight to add a splash of light if your main subject is backlit or is in the shade (under a tree, for example). Just remember that your flash will only reach 3 or 4m (10-12 ft) - beyond that, there is no point even turning it on.

Flash off
Try turning the flash off when shooting portraits indoors (you need to watch for camera shake, so turn the ISO setting up). You should never use flash in the following situations: shooting through glass; shooting subjects more than about 3m (10ft) away; photographing scenery at night; in macro mode.

▲ Straight flash (top) is often unflattering, and the scene is robbed of atmosphere. Slow-sync mode (above) - and a steady hand - together produce a much more appealing result.

▲ Over about 3m (10ft), your flash won't do anything, so don't use it for scenery at night.

Slow-sync flash
This is a special mode that combines a long exposure with a burst of flash; with practice you may find this the best possible 'party' flash mode. This is because it has the ability of flash to freeze motion, but it preserves much more of the atmosphere of the scene. The only downside is that you still have to hold the camera very steady to avoid blurriness.

CHAPTER TWO:
SHARING
PHOTOS

DON'T KEEP YOUR GREAT PHOTOS TO YOURSELF; THE BEAUTY OF DIGITAL IS HOW EASY IT IS TO SHARE IMAGES

Together, digital cameras and the Internet have completely transformed the way we share our photos with friends and family – or the wider world. Gone are the days of sorting through negatives and paying for reprints; sending pictures to anyone with Internet access takes minutes, and is also virtually free. In this chapter, we are going to look at just a few of the almost infinite number of ways we can use digital technology to not only share photos (either on-screen or as prints), but to enhance our enjoyment of special events such as weddings and parties.

number 10
CREATE AND SHARE A MOVIE ON CD

WHAT YOU NEED ✔

Software
Movie-editing application

Hardware
Digital camera with movie mode, PC and CD or DVD burner

●●✔●● **Moderately easy**
You will need to learn how to use your software to edit movies and author CDs and/or DVDs

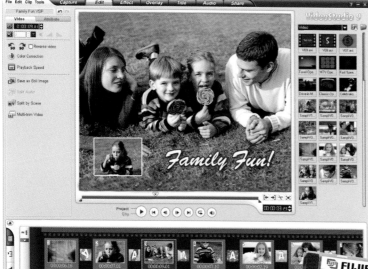

▲ **Ulead's VideoStudio is an easy-to-use tool for creating movies from your digital camera's movie files.**

Most digital cameras have a movie mode that lets you take short movie clips and record them onto the camera's memory card. You can't expect the quality that you would from a digital video camera, but some of the more modern cameras are surprisingly good. On some models you can even record stereo sound too. This feature is ideal when you want to record short movie clips but don't want to take a full-blown digital video camera with you.

Once you have recorded a number of video clips, you can download them to your computer pretty much in the same way as you would photos. The software that came with your camera will provide you with all the tools. So, how do you convert these into a proper movie? Chances are, the movie clips you have recorded are a bit rough around the edges.

There will be parts of scenes – or whole scenes – that you want to remove. And then you will want to join them all together into a single movie.

Whatever computer you are using, you will have some useful software already installed that can help you turn these rough scenes into a mini-blockbuster. Windows users have Movie Maker, whereas Mac users have iMovie. Both these applications allow you to import your video clips and manipulate them. You can even embellish the production with some special effects and titles.

Once happy with the result, you can save the movie. You can save it in one of several formats, such as AVI or MOV (MPEG), or even DV. To put the movie onto a CD that can be played on most other computers, stick with AVI or MOV. Some applications also allow you to create CDs in a special format (VCD) that can be played in most modern domestic DVD players, so your friends and family won't even need a PC to watch them.

QUICK TIPS

✔ You could burn some still images to the CD as well.

✔ You can also produce a DVD of your movie (and images, if required). You will need some DVD-creation software such as iDVD (standard on Macintosh computers) or products from Ulead (www.ulead.com) and Roxio (www.roxio.com) if you are a Windows user.

USE A SHARING SERVICE TO CREATE A WEB PHOTO ALBUM

number **11**

Don't clog up everyone's in-box with emailed photos
– use a web photo album and email them the link...

One of the greatest things about digital cameras is how easily you can share your pictures with anyone, any time, anywhere in the world via the Internet. But emailing large numbers of unsolicited pictures to everyone in your email address book – especially those without broadband access – won't win you any friends as they struggle to download 15 pictures of little Poppy learning to ride her bike.

A far better solution is to publish your images in an online album format, and simply send everyone a link to the web page so they can view the images at their leisure, and download only the ones that they want. If this sounds a little daunting, don't worry – there are an increasing number of websites that do all the work for you, and most of them also offer mail-order prints to you and your visitors. This service is not expensive, either; some are even free!

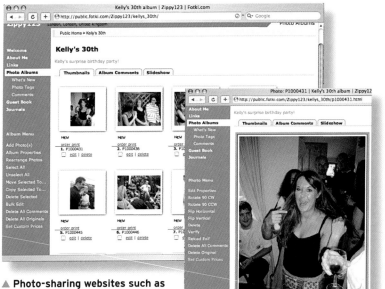

▲ **Photo-sharing websites such as www.fotki.com offer a low-cost and easy way to share your photos – and offer a printing service, too.**

Using a photo-sharing site is a great way to let everyone at a party see pictures of the event the very next day, or to keep distant relatives up to date with your family. These sites are also an excellent back-up resource that ensures that you won't lose all of your pictures should you have a computer catastrophe.

QUICK TIPS

✔ If your camera has a lot of megapixels, you might want to reduce the size of the images before you upload them to speed things up; some sites can do this for you automatically.

✔ If you want to share your photos with only a select group of people, most sites also allow you to add a password.

There are so many photo-sharing sites – with new ones springing up all the time – that you won't struggle to find one. As a start, www.pbase. com, www.fotki.com and www.photobox.com are all worth checking out.

SEND SOUND FILES VIA EMAIL

Send an email that speaks to the recipient using another of your digital camera's unsung features...

Not content with deputizing as a movie camera, your digital camera can also act as a pretty effective sound recorder. Admittedly, the sound quality will not be up to the mark of recording the rough tracks for the next best-selling album, but it is more than sufficient for sending voice messages along with your emails.

Depending on your digital camera model, you can record sound either as an attachment to images (the rationale being that you will want to record pertinent information for that image) or as a discrete sound file. You will have to refer to the manual to discover the ways in which your model handles sound.

Whatever the method, once the sound files are on your computer you can attach them to any email. And the good news is that, unlike movie or photo files, sound files are generally small so you won't have to worry about compressing them!

QUICK TIPS

✔ Don't be afraid to rehearse your greetings or message. All you'll use up is time!

✔ The voice memo function can be a very useful way of quickly adding information (such as location) to an image.

SEND MOVIES VIA EMAIL

If you've used your digital camera to record movie clips, attach them to email to create a very memorable message!

If you have tried sending photos with your emails, you will have discovered how simple it is and also how much more exciting it can make your emails. You probably won't be surprised to learn that you can also attach movie files to your emails and make those emails animated.

If you have already read up about emailing photos, you will have realized how, in the interests of efficiency and speed of mailing, it is a good idea to reduce the file size of photos before sending them. You can do this using one of the compression programs available on the Internet (many

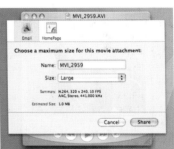

▲ **QuickTime is an ideal utility for preparing your movie clips for emailing. Select a movie size from the Share drop-down menu.**

of which are free to use) or an application such as QuickTime.

In QuickTime's Share options, you can choose whether to produce a small-, medium- or large-sized movie file. As a rough guide, a 20s Large movie file will be about 1MB in size. This is fine for all but the slowest of Internet connections, and on a par with a single photo that has been mildly compressed.

QUICK TIPS

✔ Edit your movie clips before preparing them for emailing. As with photographs, you don't want to send anything that is not up to scratch.

✔ Many cameras have an 'email' setting for the movie mode, which produces a very small file.

number 14 CONNECT TO A TV FOR A DIGITAL SLIDESHOW

The one thing virtually everyone has in their front room is a television. Why not make use of it to share your photos?

It's great to be able to view your photos immediately on the LCD screen of your camera, but it's even better to see them enlarged on a television screen. Virtually every new digital camera comes complete with a simple cable that you can use to connect your camera and television. You can then use the camera controls to run a digital slideshow. Some cameras will even change images automatically and let you sit back and enjoy. And of course, if you visit friends and family you can show them your photos without needing a computer.

Some modern cameras have fairly sophisticated slideshow options, including a choice of transitions and the ability to tag images for inclusion in custom shows.

For an even better experience, you can invest in a TV viewer such as the SanDisk Photo Album shown on the right. This is a mini set-top box that can remain permanently attached to your television. Simply slip in your camera's memory card (it's compatible with virtually all kinds) and use the infrared remote to control the show. Some of these devices will even replay sound files and movie files recorded on the memory card.

Advanced techniques

Why not prepare a more sophisticated slideshow on your PC and use your camera to show it on any television? Start by selecting the images you want

to include and making copies of them in a new folder. You can now add captions, do any corrections or special effects you want and save them back onto the memory card using a card reader or the camera's USB connection.

For this technique to work you need to remember a couple of things. First, any files you change (by adding captions or whatever) must be saved as standard JPEG files, and must use the same naming conventions (DSCF001. JPG, for example) as your camera, or it won't recognize them. The easiest way to do this is to simply not rename them. Also, most cameras only look for images in one place on the memory card, and the folder structure can be quite complicated. The easiest way to make sure you've got it right is

to format the card in-camera, then take a single shot. When you look at the card using your computer you'll now be able to see where the camera stores images, and to copy your chosen slideshow files into the same folder. You can now delete the test shot you took and you're ready to roll!

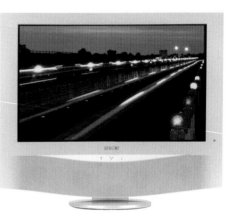

▶ **Devices such as SanDisk's Photo Album make it simple to watch your photos – and movies and music too – on a television.**

STAGE A MINI EXHIBITION

number 15

Photo exhibitions don't have to be grand-scale events held at prestigious venues. After a few months with your digital camera you've probably amassed a number of good photos that could stand shoulder to shoulder with those of professionals, so why not stage your own mini exhibition?

There are lots of local venues that are ideal for displays. Obvious choices would be libraries (which often feature shows from local photographers and artists), village halls and community centres. Less

obvious, but just as receptive, are restaurants, sports clubs and even some local photo shops.

Whatever your venue, make sure you pick only the cream of your collection and give each a high-quality frame that complements the subject. Don't forget to provide captions for each photo, including your contact details. Most importantly, add on the price to purchase each print – framed or unframed. Not only could you gain a little notoriety, but earn a modest income too!

QUICK TIPS

✔ You will probably have more success at selling your photos if they have local relevance. Feature some shots of your town or village for some guaranteed sales!

✔ If you have the opportunity to display your prints for a long period, change the displays periodically. Move the photos around and add new ones. If you've sold some, you might get an idea for the more saleable items and can add more of that subject.

SHARE YOUR PHOTOS VIA EMAIL

number 16

Share photos with friends or family around the world by sending them as email attachments.

Not only does digital technology let you take and see photos almost instantly but enables you to share those photos quickly, too. You can add a photo to an email as an attachment in the same way as you would attach a document. Some mail programs will let you drag an image file and drop it directly onto an email; others will ask you to select the file as an attachment from a drop-down menu.

Is there anything else you need do? Well, you may need to rescale your photos before sending them. If you are fortunate to have a high-resolution camera, the photo files it produces can be large, and if you want to send a number

of photos it could fill people's mailboxes. You can rescale your photos to make them smaller – both in resolution and file size – and consequently easier to email from within your image-editing software.

▲ **Many image-editing and browsing applications will automatically rescale images and attach them to emails for you.**

QUICK TIPS

✔ When you rescale your photos, do so with a copy of the original image rather than with the original image itself. Then, if you want the best quality print from that image file, you will still have the original to work with.

✔ If you or your recipients have limited space in your mailbox for sending and receiving emails, remember that image files can quickly fill those mailboxes. Remember to clear out your mailbox regularly to prevent it becoming blocked.

number 17
LIVEN UP A WEDDING WITH INSTANT PHOTOS

Partner your digital camera with an instant printer and enliven a wedding reception - or other event - you could even make some money too!

With a memory card loaded with images, we generally wait until we get home and connect to the computer. But there's an even quicker way to get real hard-copy photos out of your camera: direct connection to a dedicated photo printer. More compact and portable than the general-purpose inkjet printers we have attached to our computer, these are great for producing standard-sized prints directly from the camera wherever you may be.

There's nowhere better to make use of a printer than at social occasions, and weddings especially.

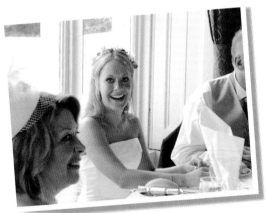

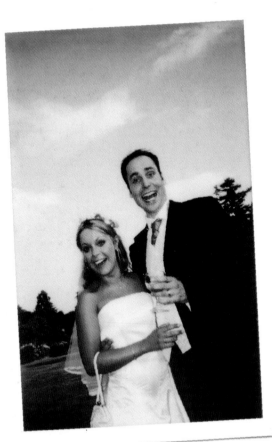

#017

QUICK TIPS

✔ Go for the informal shots. Let the pro photographer get the groups and formal shots.

✔ Offer a printing service for other guests who may have compatible cameras.

✔ Pack sufficient paper for your printer. Many photo printers use special packs that may not be as readily available as those for conventional inkjet printers.

✔ Buy a small photo album before the big day and take it along with you. You can then choose the best shots of the day and give the happy couple a unique present to take on honeymoon with them.

✔ Have someone photograph the guests as they arrive for the wedding and then pin the prints up at the entrance to the reception.

✔ After the event, burn the best of the photographs onto a CD or DVD and send copies to the couple and to other friends and family.

✔ Consider hiring a video projector to show the reception guests highlights of the day during the meal and the party afterwards.

At these events, people are in high spirits and the atmosphere of the moment is perfect for showing off your photo skills and even selling copies.

You can review the (probably huge) number of shots you are likely to take and print only the best. Or you could print on demand for those guests keen to take a keepsake of the day away with them. As more and more photographers are finding – especially those that call themselves semi-pros – it's far, far easier to sell photos on the day than it is anytime later.

Any problems? Just a couple to be mindful of. Promoting or selling your photos at a wedding could put you in direct competition with the official wedding photographer who has a living to make from events. You should, of course, always get the permission of the happy couple at the wedding before setting

WHAT YOU NEED ✔

Software
None

Hardware
Digital camera and direct-print photo printer, consumables

✔●●●● **Very easy**
Just point, shoot and print!

up your mobile print studio, but often they'll be more than happy to get a collection of informal and impromptu photos of the kind pro photographers rarely take.

As only a few photo printers are battery-powered, make sure you will have power at the venue. It is standard if the venue is a hotel or similar, but in a marquee you may not be so lucky.

🔍 ALSO SEE...

■ Liven up a party with a digital camera and projector - p.26

number 18 LIVEN UP A PARTY WITH A DIGITAL CAMERA AND PROJECTOR

Beg, borrow or hire a video projector for some large-scale fun at parties.

▲ Many modern projectors have built-in card slots.

As with karaoke, people who are in a party mood don't mind making fools of themselves – so why not let them do it in a larger-than-life way by hooking your digital camera through to a video projector. Suddenly, your live snaps don't just get recorded discreetly on the camera's memory card but are emblazoned across a huge screen.

You can hire LCD projectors from specialist companies, but try asking around before spending any money. Many businesses have portable data projectors for presentations, and as long as you cover the insurance it shouldn't be too difficult to talk the boss into

letting you take one home for the weekend. If the party is being held at a hotel or similar paid-for venue, it's also worth asking in advance whether they have presentation equipment themselves.

Arrive at the venue early and get your equipment set up before the guests arrive. It is up to you how technical you want to get; many modern projectors have built-in card slots and will produce slideshows without any additional equipment. Alternatively, all have a composite video input, which can be attached to the video output of your camera, allowing

the camera itself to produce the slideshow. This has the disadvantage that you can't shoot and show the pictures at the same time. The final option is to hook up a laptop. This is more work, but allows you to use slideshow software to produce more impressive-looking results – and lets you keep a copy of every shot.

▲ Of course, fun is not just for kids!

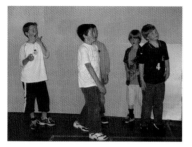

▲ Children, like these at an end-of-year school party, are only too eager to perform – especially when actions are displayed super-sized!

SHOW OFF YOUR PHOTOS ON A PSP™

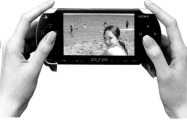

The same pin-sharp LCD screen that makes game play so realistic can be used to display your best photos anywhere.

Putting a photo collection on to a PlayStation Portable (PSP™) is a simple procedure. However, unless you have a very modest collection of images that you want to transfer, you will probably need to invest in a larger Memory Stick than the one that comes as standard. Go for a really big one, such as 1GB, and you will have room to store your images, and maybe even some movies!

[STEP 1]

Format your memory card in the PSP. This will ensure that the card is formatted in the correct way and that all the appropriate sub-directories are also included. This is a crucial step – a card formatted on a computer or in a digital camera, say, will probably not have the correct formatting.

[STEP 2]

Connect your PSP to your computer using the USB cable provided. If you're using Windows XP, you'll see the memory card when you use Explorer or in the External Devices of My Computer. On Macintosh computers, the memory card will appear on the desktop. Copy your selected images to the folder marked PHOTO. Once loaded, your PSP will display the number of images in the menu.

[STEP 3]

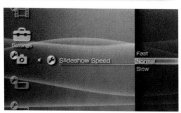

To view your images, select the memory card from the on-screen menu and then the Photos folder. You can then use the PSP's controls to navigate your photo collection. In Settings you can set up your photo collection to run as a slideshow and set the speed of playing.

QUICK TIPS

✔ If you have pre-formatted a Memory Stick, you don't need to connect your PSP to load images. Instead, you can insert the Memory Stick directly into your computer (if it has an appropriate slot) or via a memory-card reader and copy the images over to the same folder.

✔ To store more images on a small memory card, resize copies of your photos to around 480 pixels wide to match the PSP's screen.

✔ Don't forget it's not only Sony's PSP that can double up as a portable photo album; many MP3 players (such as the iPod, right) offer the same functionality – although few have such an impressive screen.

CHAPTER THREE:
USEFUL TRICKS

IT'S AMAZING JUST HOW MANY PRACTICAL USES THERE ARE FOR A DIGITAL CAMERA...

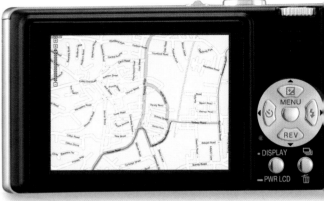

The earliest buyers of digital cameras were rarely 'photographers'; they were generally business-users, who found that the huge savings in film and printing – plus the ability to transmit images from remote locations – easily offset the high cost of the cameras themselves. Now that digital cameras are commonplace, people are starting to discover that they have a surprising number of practical uses beyond mere picture-taking.

In this chapter, we look at just a few of the almost limitless number of ways in which a digital camera can be put to use, including documenting your hobbies, making insurance records, selling your unwanted possessions, and even redecorating the family home. Most of these ideas require little more than a digital camera, and many work with camera phones, too.

number 20
TAKE YOUR DIGITAL CAMERA SHOPPING!

If you're hunting for a special something – or even if you've got a poor memory for what-you-saw-where – why not let your digital camera or camera phone help out? A quick shot of the item, in its setting so that you'll remember the location, is a terrific aide-memoire. When you've visited the twentieth shop of the morning and need to review all those possibilities, you don't have to rely on memory and can make the best possible comparison.

Not sure if that new outfit suits you? Take a picture of yourself in the changing room mirror and get a second opinion when you get home. I've avoided more than one costly mistake by doing this!

With a camera phone in hand, you've also got a great way of going shopping for

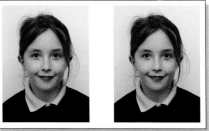

▲ Could you remember all the options, precisely, and which shop offered them, without some photographic evidence?

QUICK TIPS

✔ Remember to tell the shop assistant what you are doing, especially if you're in a very expensive jewellers'!

✔ If there are signs up saying 'no cameras', take note. You don't want to be asked to leave before identifying the perfect gift.

a friend or loved one. How often have you gone shopping and found that the description you were given of an object wasn't explicit enough? Or it was just plain wrong? Take a photo, email it back and you can get the all-clear straight away. It's so much simpler than having to go back the next day and join the returns queue!

number 21
CREATE AN INSTANT PASSPORT PHOTO

Armed with a digital camera, there's no need to pay a professional photographer or

QUICK TIPS

✔ Make sure you read (and double-check) the passport application form before shooting your photos. Agencies are very stringent about the rules and will return photos and documents that don't conform to their criteria!

✔ Generally this procedure is easier if you use flash.

find a photo kiosk for your passport or security pass photo (and you can try as many times as you like to get it just right). You don't even need much in the way of photographic skills to produce your photos. However, it is essential that you follow the rules and guidelines set out by the passport (or other) agency.

Generally, you need to provide a head-and-shoulders image against a plain white, light or off-white background (a plain painted wall, 60cm–1m/2–3ft from the subject, is ideal). Agencies also stipulate that the subject should not be

▲ Save the cost of professional passport photos by taking your own.

wearing glasses and should be a certain size in the image. Invariably you have to provide the finished prints (usually at least two) to a given size. Once you've taken the photos, print them to the required size. We used the print utility in the image-editing software to produce two identical prints on one piece of paper.

number **22**

TAKE BETTER PICTURES FOR ONLINE AUCTIONS

With the prevalence of online sites for anyone to sell unwanted items to the highest bidder, including an eye-catching image as part of your sales pitch not only lets potential buyers see what they're being offered, but also increases the chance of a sale.

WHAT YOU NEED ✓

Software
Any image-editing program

Hardware
Digital camera with macro mode, tripod will make it easier, some white card for a background

●●✔●● **Moderately easy**
Mostly just camera technique

If you really want your item to stand out, choose a neutral background. White is best (unless the object you're selling is the same shade!), with grey or black being acceptable alternatives.

Another thing to watch out for is creating unattractive shadows around your subject – this is an inevitable (and unwanted) result of using your camera's built-in flash at close range. One way of getting around this is simply to turn off your camera's flash. Unless it's a bright day, you will need to fix your camera to a tripod to avoid camera shake.

▲ Quick snaps won't do your item any justice – and won't help it sell!

▲ Flash – especially at short distances – will rarely produce the best results.

▲ The wide end of your zoom will distort the object that you are photographing.

▲ Use the right settings and a white background and you'll have the bidders in a frenzy!

QUICK TIPS

✔ Use the macro mode on your camera for sharper pictures and use the long (telephoto) end of the zoom to avoid distortion.

✔ Watch out for any colour casts – set the white balance to the incandescent preset if you are shooting under household lights.

✔ Clean up the image in your editing program – but don't be tempted to hide blemishes!

While most of us don't have anything approaching a professional studio at home, small tabletop set-ups can be purchased relatively cheaply if you are aiming for more professional results. Alternatively, utilizing available light – placing an object on white card outdoors, or on a window ledge, for example – can produce surprisingly professional-looking results. You will find that the diffused light from a window on an overcast day produces the best results. And it won't cost you a thing.

KEEP A PHOTOGRAPHIC INSURANCE RECORD

number 23

Take the time now and your digital camera could save you more than time should the worst happen – it could save you a fortune.

Take a look around your house and imagine trying to list every item in every room, in the event of a major insurance claim. Losing everything to fire, flood or theft is a nightmare we'd all like to think won't ever affect us, but an hour or two spent with your digital camera today could save you a huge amount of time, effort – and money – should the unthinkable ever happen.

Room by room
Start by taking pictures – in good light – of every room in your home. Use the wide end of your zoom to fit as much in as possible, and take as many pictures as necessary to show the entire room and all its contents. This will be a valuable aide-memoire should you ever need to claim for everything you own. Zoom in, or move closer, to any

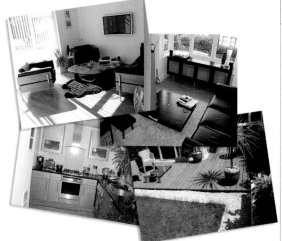

items, such as shelves or dressers, that have smaller objects on them. Don't worry about how many pictures you take – the more the better. Don't forget about any outside areas.

Valuables
Any particularly valuable items should be photographed individually, ideally on a plain white background (card is fine). Wait for a bright but slightly overcast day and shoot everything in one session using the light from a large window (on-camera flash can blow out details when used at short distances). For very small items, such as jewellery, use your camera's macro mode and try to include some size reference (a ruler is ideal, or a coin will do perfectly well). It is worth photographing any expensive item separately. Ideally, you should include a macro shot of the serial number of any electrical items.

Clothes
If you have a lot of clothes, or if you have any items that are particularly valuable, it's also worth photographing them. Again, the best approach is to shoot

▼ Include a size reference when shooting small, valuable items such as jewellery.

WHAT YOU NEED ✔

Software
Any image-editing program

Hardware
Digital camera

⬤◐○○○ **Very easy**
Mostly just camera technique

the garments against a white background, on a hanger.

Remember to update your photographic insurance inventory every so often, or whenever you buy anything of any value.

Storing the pictures
When you have photographed everything, collect all the images together and burn them onto a CD, then create a back-up. Put one of the CDs somewhere safe, away from your house. Keep the other one at work. For extra safety, store a copy of the images on a photo-sharing website in a password-protected album (see p.20).

AVOID ARGUMENTS AFTER A ROAD ACCIDENT

Few things can be as distressing as being involved in a road accident. Even a minor bump can lead to stress and trauma even if no one has been injured. The effects of an accident can be compounded as other parties and insurance companies argue about the circumstances.

By taking pictures of the scene, you will not only find it a lot easier to recall the exact train of events when you are filling in the claim form, but you will have valuable evidence should there be any argument over exactly what happened.

I would always advise carrying a camera with you at all times anyway – just in case you see the opportunity for the shot of a lifetime – but at times like these it can really prove useful.

Of course, if you don't have your camera to hand, you could use your phone camera, or, if you really want to be prepared, buy a cheap disposable film camera and leave it in the glove compartment.

Take shots of:

• the damage to your car and the third party and damage to property or road signage.

• the registration plate of any vehicles involved.

• a general view of the road and accident.

Not only does this information save your memory – and is much more accurate – it serves to get more objective treatment by all concerned who no longer need to rely on memory.

If any one is moderately or badly injured at the scene, the police will need to be called and will attend. They may assess it necessary to take their own photographs. Don't rely on these instead of your own, as they will probably not be made available to you or your insurance company.

QUICK TIPS

✔ Remember that film in cameras deteriorates with time. Subject that film to the temperature extremes of a car and the deterioration can accelerate. Think about replacing your in-car camera annually. Perhaps each time you get a service?

✔ Don't use a high-value camera – even if it's a spare – in the glovebox. It will also be affected by temperature changes and you could find yourself a victim of crime when it is stolen – with no camera to record the event!

✔ Avoid risk: don't risk a second accident when shooting photos – watch out for other traffic!

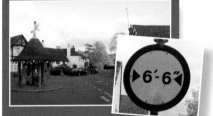

▲ Record details of the road layout, and any signs or environmental factors (frost and ice, for example) that might have contributed to the accident.

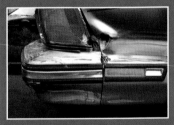

▲ Shoot photos of details of damage as well as the whole car.

▲ Don't forget to do the same for other vehicles involved. It saves much time and argument about the nature and extent of the damage later.

USE YOUR DIGITAL CAMERA AS A WEBCAM

number 25

Webcams are increasingly popular both for face to face conversations over the Internet and for displaying – again over the Internet – events unfolding.

Do an Internet search and you will see webcams displaying events as disparate as road conditions, secret wildlife conditions or even interplanetary exploration. And volcanocams give you the sort of view you probably wouldn't want to experience for real!

If you fancy setting up your own webcam, or would simply like to have video phone calls with relatives and friends overseas, don't spend money on a webcam

just yet. Check your digital camera's instruction book. Many digital cameras can be used as a webcam, and often outperform off-the-shelf webcams.

Cameras offering this feature will usually come bundled with software for setting up a webcam. If yours didn't, or you have put the original driver disks in a place so safe not even you can find them, don't worry. Run another Internet search on webcam software and you will soon find there are many manufacturers' and third-party software applications available to download that will do the job perfectly. All you need do after that is choose what you want to do with your webcam.

Any major drawbacks? The only really significant one is that if you use your camera as a camera most of the time you can only set it up in between assignments, holidays or days out as a webcam. This rather precludes its use as an always-available eye on your world. But, let's face it, for most of us, it is the thrill of talking to and seeing our friends and relatives that is the key use for a webcam. And for that job, your digicam will be just perfect!

QUICK TIPS

✔ When setting up your digital camera as a digicam, try and align it with the screen of your computer. Then, when you talk to someone, your eyeline and theirs are close together.

✔ Watch your distance. Check your camera's manual to see how the camera focuses when in webcam mode. Some switch to fixed-focus (usually sharpest 0.75m/2¹⁄₂ft from the lens).

✔ Check the sound. Not all digital cameras set to webcam mode transmit sound. If this is the case with your model, try using a separate microphone or, if appropriate, the one built in to your computer.

▼ Simple and easy to use, webcam software makes it possible for you to see and hear your friends and family, no matter where in the world they happen to be.

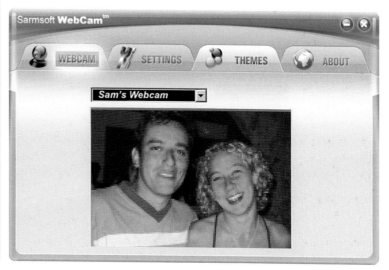

number **26**

REDECORATE YOUR HOME... DIGITALLY!

Save yourself from a costly mistake by trying out a new colour scheme without even a splash of paint!

One of the biggest problems with redecorating your home is that, unlike the highly paid interior designers on the TV, few of us can really visualize the result of painting the walls a different colour – or even hanging a different picture – without actually doing it.

If you're one of the people who can't actually see from a smear of paint from a test pot how the whole wall will look, fear not; with a digital camera and some basic image-editing skills you can redecorate every room in your house on-screen, and make sure you don't end up making an expensive mistake!

For this step-by-step, we're using Adobe Photoshop CS, but the technique is so simple that it can be done using any imaging application that offers layers. You will need a basic knowledge of how to use your program, but you don't need to be an expert to produce a result that will give you a good idea of how changing the colour of your walls will look.

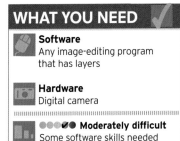

[STEP 1]

Start by taking a picture of the room(s) that you want to visit with the virtual redecorator. If, like me, you've got white walls, you're going to find this a lot easier (or at least the result will be a lot more realistic). Use the widest end of the zoom, and get as far back as possible to include as much of the room as possible in the shot. Open the file and create a new transparent (empty) layer in the document.

[STEP 2]

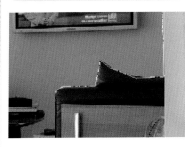

Using the polygon lasso tool, select the entire wall area. Choose a paint colour for your walls (this can be changed later so don't worry too much about getting it exactly right).

[STEP 3]

Once you've selected the wall(s) you want to change, make sure you are working on the new (empty) layer you created in step 1 and use the paintbucket tool to fill the selected area with solid colour.

[STEP 4]

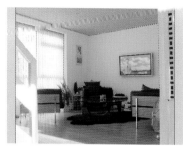

If your starting walls were white, you can make the effect a lot more realistic by reducing the opacity of the paint layer or (as here) changing the layer blend mode to 'Color'.

[STEP 5]

If you like things neat, zoom in and use a small paintbrush (or the eraser if necessary) to tidy up the edges of your new paint job.

[STEP 6]

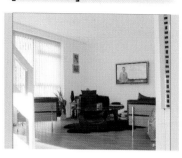

For this makeover, I'm also going to experiment with different ceiling colours, so I've repeated the whole process (with a new layer) to repaint that section of the image.

[STEP 7]

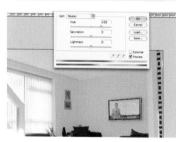

Once you've saved the layered file, you can experiment with different colours by using the Hue /Saturation/Lightness controls on the paint layers. Hue changes the colour, saturation the strength and lightness the... lightness!

[STEP 8]

The resulting image should at least give you an idea of how your room would look if you got to work with a real paintbrush, and it takes a lot less effort!

[STEP 9]

If you're considering wallpapering, try using the 'pattern' option in the fill menu – if you know your way around Photoshop you can even make your own patterns using images of real wallpaper.

QUICK TIPS

▶ These techniques don't only apply to repainting or recarpeting; this room has a large painting on the wall; with a few minutes' work we can see how a new one would look.

▶ To add 'carpet' to wooden stairs you'll need to use some simple shading (filling areas with a slightly darker tone) or it won't look right.

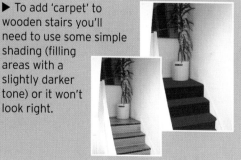

PRINT YOUR OWN CD & DVD LABELS

number 27

Create professional-looking CDs and DVDs by printing your own photos and graphics on to disks.

WHAT YOU NEED

Software
Label-printing software

Hardware
Printer

✔●●●● **Very easy**
Just follow the instructions!

If you burn your own music compilations, movies or photo collections onto CDs or DVDs, it's simple to print a great cover so it looks just like a commercially produced disk. You can create labels from scratch, but it's easier to use software specially designed for the job. Printers capable of printing disks directly will come with disk-printing software, and self-adhesive paper often also comes with templates, or you can search on the Internet for shareware. Either way, creating impressive labels is easy. Here we have used Epson's Print CD, a utility that is provided with many Epson printers.

[STEP 1]

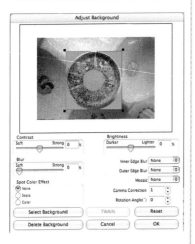

Select an image and import it into the software. You will need to choose an image that matches the format of a CD or DVD. Because your image will end up doughnut-shaped, you need to ensure that the main subject of the photo is not dead-centre or it will be obscured by the central hole. You can fine-tune the CD template by adjusting both the position and the size until you get a layout that looks effective.

[STEP 2]

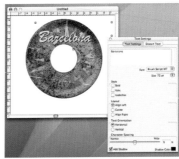

Add text to complete the layout. Here, we've added an appropriate title. The dialog boxes will let you choose any font from your computer, change the colour and size. You can reposition the text as you wish on the template. Often adding a drop shadow, as here, makes it easier to read text when the background image is cluttered.

[STEP 3]

Now print your disk. You should be using disks that are specially designed for surface printing. The characteristics of the surface of these disks closely matches that of printing papers, so the results should be as good as those you would expect to obtain from printing on good-quality inkjet paper.

QUICK TIPS

✔ If your printer doesn't allow printing directly onto a disk, buy a pack of disk labels and print directly on these. Disk labellers usually come with a tool to ensure your label is precisely centred on the disk prior to sticking it permanently to the surface.

✔ You can create labels and inserts for jewel cases and DVD cases in a similar way. You will end up with results that you will be proud to display with your purchased disk collection!

36

number 28 · ALWAYS CARRY YOUR CAMERA – AND USE IT AS A NOTEBOOK

Once you're in the habit of carrying your camera with you at all times you'll find it an incredibly useful 'notebook' for grabbing quick snaps of things you might otherwise forget about. Passing a restaurant or shop you fancy coming back to another day? Take a picture of the sign, making sure you get the telephone number clearly in the frame. From photographing your meal in a restaurant to snapping 'for sale' signs when you're house-hunting to keeping track of job interviewees, there's no end to the uses you can put your camera to... as long as you remember to always keep it with you!

number 29 · RECORD GARDEN PLANTING FOR COLOUR-SCHEMING

Whether you are green-fingered or ham-fisted, your digital camera can help you create successful colour schemes for your garden.

Unless you are a seasoned expert, getting your garden colour-schemed successfully throughout the year can prove a little hit or miss. Most of us like a colourful garden but tend to be driven to impulse buys rather than work to a plan when establishing planting. Sadly, as the seasons come and go, we tend to forget what we have planted and when each plant is at its floral best.

Why not take a series of photos of the garden in different seasons? You can see the progress of the planting, how colours juxtapose or clash and identify those flat periods when there seems to be nothing of note in bloom. It then becomes a simple matter to find plants to fill those gaps, or balance the colour and plant them at the appropriate time to deliver results that make you look like a true horticulturalist.

And a beautifully colourful garden is a dream location for taking great photos. The verdant growth is ideal for general photography, while details such as blooms are great for practising your macrophotography. The polychromatic backdrop is also the perfect foil for wildlife shots, such as squirrels foraging for nuts, birds collecting for nests or bees collecting nectar.

QUICK TIPS

✔ Take photos from the same position every month (more often in the summer) to produce a 'time lapse' view of the garden, showing the progress of the growth throughout the year.

▼ Your collection of planting photos is ideal for constructing a mood board of your favourites and identifying successful planting or shortcomings in the design.

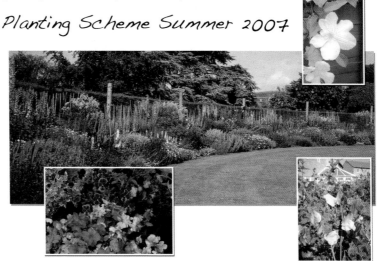

Planting Scheme Summer 2007

number 30 TURN YOUR CAMERA INTO A SATNAV... OF SORTS

Find and save maps or directions and make use of your camera's screen to find your way around...

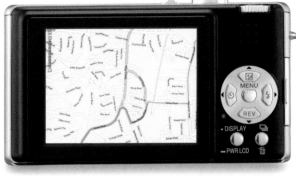

In-car satellite navigation systems are increasingly common, and the advent of websites such as Google Maps means free route-planning is available to anyone with an Internet connection. But that's not much use when you're trying to find somewhere on foot. With a little planning and a few minutes' work, you can turn your digital camera into a handy map.

Once you've found the map you want on the web, do a screen grab (press the Prt Scr button in Windows) and paste it into a new document in your image-editing application. Now simply save the image as a standard JPEG file and copy it onto the memory card.

You will need to follow the normal naming rules (use the same file-naming convention as the camera itself) and put the file(s) in the right folder on the card to get the camera to display the map (see p.22). It is worth experimenting with this before you set off on your journey. Using the playback mode controls you can zoom into areas of the map, and, of course, you can save as many as you want to make sure that you never get lost!

🔍 ALSO SEE...
■ Make a TV slideshow - p.22
■ Business presentations - p.39

▶ **Stumped by a language barrier? Take – and store – photos on your mobile phone or digital camera.**

TOP TIP: MAKE YOURSELF UNDERSTOOD IN A FOREIGN COUNTRY

Know the Sri Lankan for rickshaw? The Japanese for coffee? Or even the Chinese for Forbidden Palace? If not, you're certainly not alone. Although many of us can get by in some countries' native languages (even if we have to resort to a little gesticulation), other languages and cultures can still prove problematic. And as we seek out more and more obscure corners of the world on our travels, that problem can only get worse.

Certainly, a phrasebook can help, but wouldn't visual cues be even more effective? So, next time you take off for Thailand, Laos or even Tokyo, take photos of those key elements - the hotel, a taxi, rail station, toilet and anything else you might have to ask directions for.

With some forward planning, you could even work your way through a guidebook and take photos of all the points of interest you want to visit (or download low-resolution pictures from the Internet). Then, when you get lost, flick through the photos until you find the shot you want. Show it to a local, complete with a puzzled expression, and you should soon be on your way!

MAKE BUSINESS PRESENTATIONS

number 31

Visiting customers and don't want to carry a laptop?
Fear not; once again your camera comes to the rescue...

If your job involves making on-screen presentations to customers or clients, you will be aware of the pain of carrying a laptop with you. For those times when you can't, or don't want to, lug the laptop to a meeting, why not put your digital camera to use? Carrying your presentation on a memory card could also get you out of a tight spot if you realize half-way up the motorway that your power cable is still on the kitchen table...

Of course, there are limitations; you can't use all those fancy PowerPoint animations and you need a display with a composite video input (which covers most plasma screens and all data projectors). Also, you won't be able to make any last-minute changes.

Producing a camera-based presentation is simple; PowerPoint allows you to save each slide as a JPEG (640 x 480 pixels should be plenty); then all you need to do is to rename them to a format the camera will understand (i.e. P100001.JPG, P100002.JPG, etc) and copy them into the right folder on your memory card (see p.22 for tips on how to make sure the camera will display the slides).

You will need the AV cable supplied with the camera to connect to a television or projector. You then simply switch to playback mode and scroll through the presentation slides using the usual controls.

▲ **PowerPoint lets you export each slide as a separate JPEG image.**

▼ **Don't forget the supplied AV cable – you will need it to attach the camera to a display or projector.**

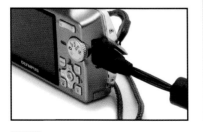

QUICK TIPS

✔ Pick up a cheap phono-to-SCART connector to ensure you can attach to any TV.

✔ Make sure the camera recognizes the files and displays them properly before heading off.

▲ **Most projectors and TVs have composite video inputs.**

ALSO SEE...

■ Make a TV slideshow – p.22

KEEP YOUR MOBILE PHONE PHOTOS ON YOUR PC

number 32

Don't lose track of those memorable photos tucked away on your mobile phone. Download them to your computer for posterity!

It's great to have a camera phone. You instinctively carry your phone everywhere with you, so you will always have a camera to hand too. And the best thing is that most phones today can take some pretty good photos. It doesn't take long to build up a collection of images on your phone's memory card, most of which you will want to keep. So why not make sure you keep them extra-safe by downloading them to your computer? Here are just a few ways:

Use your memory card
The memory card in your phone is compatible with many card-readers designed for digital cameras. Take the card out of the phone, slip it into the card-reader (some of the smaller cards may need to be placed into an adaptor first), and wait. In a few moments your computer will detect the card and prompt you to download the images. Even if it doesn't (as in the case of some older versions of Windows), use Windows Explorer to find the memory card, click on it and drag the images to your hard disk. Mac users will find that a memory card with images will automatically open iPhoto and prompt you to download into a folder. Whatever the method, just remember to put the card back into the phone afterwards!

Direct connection
Many mobile phones come with software to synchronize the phone and equivalent utilities (contacts, calendars and the like) on your computer. You can connect phone and computer and synchronize using a USB cable. You can also use this to transfer photos. In some cases the transfer is automatic; otherwise, you may have to prompt the computer – in a 'Transfers' menu. This is often the fastest way to download. This is useful if you have lots of photos to transfer.

Bluetooth
The high-tech solution for transfers is Bluetooth. This technology, which is built into many phones and an increasing number of computers, lets phones and other peripherals communicate wirelessly. You will

need initially to set up both phone and computer to 'see' each other. This is a security measure that ensures that no other Bluetooth device can see your data. Once paired, you can send your photos direct to your computer. There is no memory card to worry about, nor a physical connection to make.

QUICK TIPS

✔ Don't walk around while there's a Bluetooth connection in place. Most Bluetooth devices have a very limited range and you might break the connection.

✔ Some online photo-sharing services allow you to upload images via Multimedia Message Service (MMS).

KEEP A RECORD OF A MAJOR PROJECT

Ever noticed how much easier it is to dismantle things than to put them back together?

A digital camera can be an extremely useful tool when undertaking any major construction or repair project. From DIY car repairs, to upgrading your computer, to fixing a leaky tap, we have all experienced the sinking feeling that comes with the realization that it is a lot easier to take things apart than it is to put them back together.

And if you have ever fixed something and found yourself with some spare parts that don't seem to fit anywhere, a digital camera can help identify where you went wrong.

▼ **Documenting car and PC repairs and upgrades every step of the way can make retracing your steps a lot easier.**

The idea is simple; just take pictures as you go along, recording every step of the project. That way, you will find working out what went where, and what goes back where, a lot easier. If you're making something, it is a lot easier to recreate what you have done if you have documented the process with a series of quick snaps along the way. With no film to waste you can take as many pictures as you need.

This principle can be applied to a wide variety of projects – from hobbies such as flower-arranging, model-making and watercolour painting, to more practical matters – repairs and upgrades, for example – to major undertakings such as redecorating, garden planting and car restoration. Not only will you find the images useful should you need to retrace your steps, but the resulting album of photographs will be a lasting record of your efforts!

QUICK TIPS

✔ Use the macro mode on your camera to take sharp close-ups of details.

✔ If the camera has the option to print the date and time on each shot, you might want to turn it on.

✔ Take lots of pictures; there is no film to waste!

✔ Use flash with care – it can cause reflections and glare on what you're photographing.

CHAPTER FOUR:
TIPS FOR BETTER PHOTOS
WHERE WE TAKE A CLOSER LOOK AT HOW AND WHAT TO SHOOT FOR BETTER PICTURES

No one can tell you how to take a good picture, although many people will try. This section is designed to explain some of the tried and tested methods for producing better photographs, and to help you learn what makes pictures work.

This chapter is also designed to get you thinking about *what* you take pictures of, and how – with a little practice – you can start to *make* photographs you want to frame on the wall, rather than taking photographs you file away on your hard disk and never look at again.

The satisfaction of capturing images that you can be proud of has turned many a casual snapper into a more serious photographic hobbyist, but even if all you want to do is improve the quality of the pictures that you take on holiday or at special family events, you will find some useful information – and some inspiration – in this section. Virtually every picture you will see was taken using a fairly basic 'point and shoot' compact digital camera. You don't need a big, expensive SLR to get great pictures; you just need to develop an eye for composition and take lots and lots of pictures. There is nothing more rewarding than creating something special, so get out there and start shooting!

LEARN THE BASICS OF COMPOSITION

number 34

Disappointed with your pictures? Can't work out why the 'picture postcard' look eludes you? Here are a few quick tips.

▲ Move the subject to one side of the frame; a simple but highly effective composition tip.

There are no 'rules' to composition; what works just works. But there are several tried and tested guidelines that can be very useful to the novice photographer wanting to start to take better pictures. Learning these simple tricks will not only get you more pleasing pictures from the start, but – more importantly – will get you thinking about composition before you

▼ Natural framing helps to draw the eye into the frame.

press the shutter. And then you can start to break the rules!

Fill the frame
It may sound obvious, but many novice snappers suffer from a sort of 'tunnel vision', meaning they don't notice that the main subject is way too small in the frame.

Use framing
Whether you use a tree, an arch or a rock formation, using natural framing is visually pleasing, and draws the eye into the frame.

Give a sense of depth
The world is three-dimensional, and it's important to give your images a sense of depth. Including foreground detail in scenes will help with scale and draw the eye into the scene. Careful use of diagonals does the same thing, while at the same time adding a dynamic feel to the picture.

Move off-centre
The natural inclination to place the main subject in the middle of the frame often produces dull photographs. Simply moving the

▲ Add a sense of depth by making sure your image contains foreground and distant detail – and use diagonals to draw the eye in.

frame slightly will add impact and interest to the shot.

Vary your viewpoint
Don't just point your camera straight forward; get down low for a child's-eye point, or aim it up to emphasize scale. Experiment.

Take lots of pictures
The more pictures you take, the better you will get. And with a digital camera you're not wasting film, so there's no reason not to!

Look for inspiration
Look for pictures that inspire you taken by professionals. Get books from the local library and look at the photographs used in magazines and adverts.

▼ Varying your viewpoint is guaranteed to produce more interesting images.

number 35 USE THE RULE OF THIRDS FOR BETTER COMPOSITION

Getting a great photo isn't always hit and miss. A few rules can help make a photo something really special, and the rule of thirds is one of the most powerful.

Imagine a grid over your photo, with a pair of lines dividing the scene vertically into three and another pair doing likewise horizontally. Now, place your principal subject at one of the intersections of the horizontal and vertical lines and the horizon against one of the horizontal lines. That, in essence, is the rule of thirds. Place key elements at these points and you are almost guaranteed to create a powerful composition.

Of course, users of many digital cameras don't have to imagine. They can overlay a rule of thirds grid on the screen when composing a photo.

Instinctively, we tend to place our main subject dead-centre in our photos or, if taking a landscape,

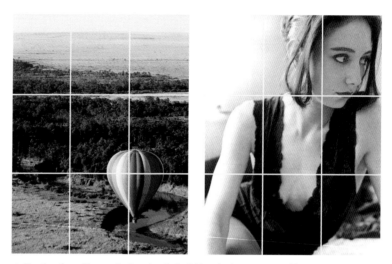

▲ Try to place the main focal point of the shot on or near the intersection of one of the horizontal and one of the vertical lines for a pleasing and dynamic composition.

▼ If the main subject is vertical, place it inside the left- or right-hand third of the frame. If you're shooting a portrait, the eyes ideally should be on one of the horizontals too.

▲ Place the horizon on one of the horizontal thirds (usually the top one) to create a more balanced composition.

▲ Very simple shots like this work well if the scene is split into thirds. Note that you don't need to stick to the lines strictly; it's the basic idea that matters.

▲ Avoid the temptation to place the main subject – and the horizon – in the middle of the frame and your pictures will have much more depth and more excitement.

place the horizon right along the central line of our view. Neither of these is wrong, it's just they don't make for a compelling composition. Move the subject off-centre or move the horizon up or down, and suddenly our photos come alive.

🔍 ALSO SEE...

■ Basics of composition – p.43

■ Basics of composition – p.43

▼ Of course every rule is made to be broken, and there are some types of shot where the rule of thirds simply doesn't apply.

QUICK TIPS 📷

✔ As with all rules, don't stick to this one rigidly. If you feel your shots will benefit from a slightly different composition, do it. Rules are meant to be broken. The advantage of digital photography is that you can experiment.

✔ To understand the many ways in which the rule of thirds can be interpreted, take a look at some photos you like and imagine the grid overlaid on them.

✔ You can sometimes crop your photographs (using software) to improve the composition and make them conform better to the rule of thirds.

✔ Many cameras have a rule of thirds grid option, which can be very useful when learning compositional skills.

LEARN TO LOOK AT LIGHT AND HOW IT CHANGES

Think photography is about cameras? What you take pictures of? Think again: the key to great photos is understanding light.

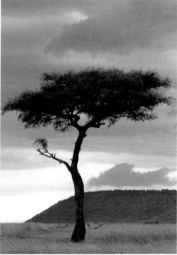

The very word photography means 'drawing with light', and it is often the quality of light that makes the difference between a stunning photograph and a mundane one.

We're not going to go into too much detail here, but it is important to realize just how much light (and we're specifically talking about available light here – artificial lighting is a whole other ball game) can change from hour to hour and month to month, and how much this can affect the pictures you take.

Seasonal differences

In the summer months, the sun sits very high in the sky, is very bright and produces a slightly 'cool' light (i.e. a bit blue). Summer light (especially in the middle of the day) tends to produce rather flat lighting, but it does make taking bright, colourful and contrasty images very easy to achieve. The deep blue skies that you get on summer days also means that you can include a lot of sky in the shot.

In the winter, the sun is much lower in the sky, and produces a much warmer (less blue) light. The

▼▶ No matter where you are in the world, the quality of light at the very end of the day is extremely photogenic.

low sun produces much longer, sharper shadows, which add depth to scenic shots, and at the start and end of the day bathes them in a warm glow that just oozes

▼ Dawn (left) and dusk (right) are amazing times to take pictures, with the light changing by the minute.

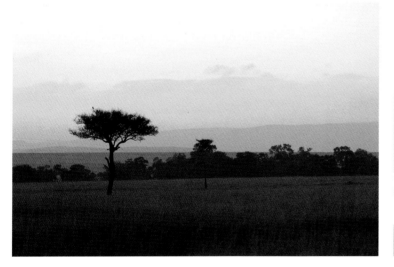

#036

▲ The end of a winter's day produces a warm, atmospheric light.

▲ You won't get a lot of colour in the winter, but you do get a very effective interplay of light and shadow.

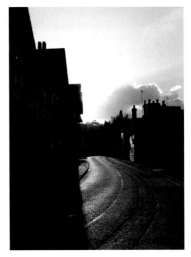

▲ The low winter sun brings long shadows and lots of contrast, so can be difficult to expose correctly.

atmosphere. The disadvantage of winter light is that it can be difficult to capture images containing strong, bright colours, and the sky is rarely deep blue.

Hourly differences
The quality and colour of light changes constantly between

dawn and dusk, whatever the time of year. The nearer you get to sunrise or sunset the warmer (more orange) the light, and the longer the shadows. In fact the worst time for most scenic shots, is, ironically, midday, when the sun is directly above. This tends to produce the flattest, least interesting shots (and is also when haze can be a real problem).

So what can we learn from this? First, that putting your camera away for the winter months

◄▼ Summer brings bright colours, blue skies and lots of sharp, contrasty shots, but watch out for haze – and a lack of atmosphere.

means missing out on some truly stunning light, and some unique photo opportunities. Second, that it is always worth getting up just after sunrise (or keeping shooting until sunset); see pp.48-49 for more on the magical hours around dawn and dusk.

The final thing is to realize that photography is about light and shadow, and that by learning to look at the quality of light you can start to produce better pictures. Shooting at midday in the summer will produce images almost without shadows, which means you will lose all sense of depth in the scene. In fact, sometimes the bright light on a hot summer's day is so harsh it almost looks like flash. To avoid the harshness – and the haze – shoot in the first and last few hours of the day in the summer (you will also get deeper blue skies).

🔍 **ALSO SEE...**
■ Use the magic hours – p.48

number 37 USE THE MAGIC HOURS OF DAWN AND DUSK

No matter where you are in the world, there's one sure thing in photography; the hour or so at the start and the end of the day offers the best light.

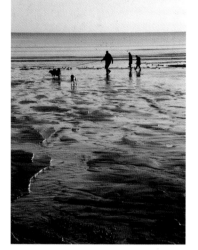

Red sky at night or red sky in the morning; it really makes no difference to a photographer. What matters is that getting up early to capture the first light of the day - and hanging around until sunset - will reap rich rewards.

The reason is simple; the quality of light at these times is unlike any other; the low sun produces a warm glow and long shadows that add depth and atmosphere to a scene. It also changes - by the minute very near to sunset

and sunrise - meaning that simply sitting shooting the same scene over a half-hour period will produce an amazing variety of colours and moods.

Of course, the shorter days of winter make catching this light

a lot easier, but you should try to get up at least one summer's morning to see the sunrise. If you are on holiday, you will have the ideal opportunity; set the alarm one morning and walk down to the beach where you can capture the full glory of the rising sun

QUICK TIPS

✔ Use the manual white balance. Cameras vary in this respect, but since auto white balance is designed to produce neutral results it can remove some of the warmth from dusk and dawn shots. Switch to the daylight setting to keep the colour.

✔ Some cameras have a sunset scene mode – try switching to this if you don't get the results you want.

✔ Take lots of pictures, and hang around for half an hour; the light changes fairly rapidly just before and after sunrise and sunset.

✔ You may want to use a tripod if light levels are very low, when camera shake can become a problem.

✔ Beaches are great for shooting at dusk and dawn, as they offer an uninterrupted horizon, and the reflections on the water are very photogenic.

(and the gradual changes in the colour of the sky), with the added benefit that there won't be hundreds of people around to spoil the scenery. The same goes for the end of the day, when the half-hour or so either side of a sunset produces some of the most beautiful light you will ever see.

Once the sun has gone down, you will notice that it doesn't go completely dark for a while. During this forty minutes or so,

the sky will appear as a dark, inky blue in your shots, making the perfect backdrop for shooting floodlit buildings. Again, it is worth checking out sunset times when on holiday and planning to get to the bar an hour or so later one evening, so you can go out with your camera. You won't regret it.

🔍 ALSO SEE...
■ Explore a floodlit city - p.56
■ Capture a glorious sunset - p.54

LOOK FOR SHADOWS IN YOUR SHOTS

We have talked previously about the importance of light in photography, but let's not forget the other side of light: shadow.

Shadows are what allows a two-dimensional image – the photograph – to show the three-dimensional depth of in the scene; without them, your pictures will look flat and featureless. In the studio (or whenever we have control over lighting), shadows are created by placing the light source to one side of the subject. This is why we recommend shooting portraits with the subject sat by a window, and why on-camera flash is so frowned upon by serious photographers.

When you're out shooting in daylight, you should try to develop the knack of looking not just at the subject you are photographing, but the interplay of light and shadow and how this shows the depth of the scene. You can even set yourself a project to go out and simply shoot shadows and nothing else; they actually make very interesting subjects in their own right!

▲▶ **Shadows give depth to an image and – if strong enough – can become the main focus of the shot.**

▲ **At the end of a winter's day, look for long shadows and warm light.**

Remember that shadows are a lot longer in the winter, and at the start and end of the day.

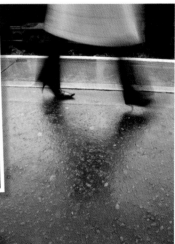

GIVE YOUR CAMERA SOME SUPPORT

number **39**

Every now and again our cameras can do with a little support. When the light level drops, even the most sensitive camera risks taking blurred shots as the exposure time lengthens.

Ask a professional photographer the best time to use a tripod, and they'll say 'always'. However, for the rest of us, that is neither practical nor desirable. It is much better to take advantage of the more compact alternatives. Let's take a look at ways of keeping that camera steady.

▲ Fuji's Cambag is an upmarket beanbag that is also lightweight – important if you will be carrying it around a lot.

A simple prop
When you need an impromptu support, you can prop your camera against a wall, on a fence or against a pillar to get a steady shot. In most cases you'll be lucky. The downside to this casual method is that you may not be able to prop your camera in precisely the direction you want or as steadily as you wish.

Beanbags
Going out for a night shoot and don't want to be too obvious about it? Take a beanbag with you so you can take advantage of the prop locations mentioned above. Beanbags are malleable enough to allow you to get good support and direct the camera precisely. You can buy beanbags in camera stores, but a homemade bag filled with dried beans can work just as well.

Clamps and brackets
If you're out shooting sunsets or nightscapes in the city, you are never very far from a fence, gate, pole or post that you can use as a camera clamp or bracket. Simply clamp it firmly to a support and fit your camera. Most clamps come with tripod-like heads that let you position the camera independently to that of the clamp. Some clamps double as tripods via screw-in legs that store in the shaft of the clamp.

Mini tripods
Tripods offer the greatest in versatility. The smaller the tripod, the less rigid they are likely to be, but most are sufficient for the slightly longer exposures that are necessary to capture floodlit buildings or a dim interior.

▼ A simple clamp is sturdy but doesn't offer much in the way of positioning versatility.

▼ Mini tripods are great for supporting a camera in any position but aren't something to slip into the average pocket.

QUICK TIPS 📷

✔ Most photo stores have lots of camera supports for you to try out before buying. Pay them a visit bearing in mind your needs for portability, convenience and support.

✔ It's worth investing in a beanbag in addition to other supports. They are easy to carry and are possibly the most versatile of options.

✔ If you've got nothing else, rest the camera on a table, fence or whatever you can find!

🔍 ALSO SEE...

■ Explore a floodlit city at night – p.56
■ Long exposures – p.66

51

number 40 DISCOVER MACRO PHOTOGRAPHY

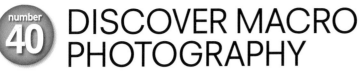

Want to see the world from the perspective of a bee or record intricate details? Then macro photography is for you.

a wealth of potential subjects inside the house, or just outside the doorstep, meaning that it's ideal for experimenting with your camera when the weather turns nasty!

Select the macro feature on your camera and you may find some of the features unavailable. Often the zoom range is limited (it may be restricted to the wide-angle position) and the flash may be disabled. Don't worry, though. You'll be using the LCD panel on the camera to preview your macro shots and so can work easily within any restrictions.

◄▼ **The natural world provides a wealth of shooting opportunities for the macro photographer. And if the weather is poor, you can do it indoors!**

Digital cameras excel over their film-based counterparts in several areas, but nowhere is this more obvious than in macro photography – the ability to take photographs of small items.

The beauty of macro or close-up photography is that you can find

▲ **There is no end of potential subjects. Remember that light – and shadow – is just as important with macro, so avoid using the flash.**

It's a good idea wherever you can to use a tripod or firm support when taking macro shots. Depth of field (the amount of depth in the photo that is in sharp focus) is very narrow when taking macro shots, so it is important that you keep the camera steady.

Wildlife

Unlike larger creatures, small insects often allow us to get sufficiently close to take macro shots. The wasp in the shot shown on the opposite page was more concerned with nibbling on a peach to notice the photographer snapping just a short distance away. You couldn't use a tripod in this instance, so take lots of shots to be sure that you will get at least some of them in sharp focus.

Flowers

A bunch of flowers from a local supermarket or florist becomes a great photo opportunity for the aspiring macro photographer. Just make sure that you provide lots of light (stand the flower on a windowsill, or outside) and you are almost certainly assured of some good shots.

Models and hobbies

Though the scale may sometimes be greater than that of traditional macro photos, models are ideal subjects for the close-up photographer. The photograph

of a recreation from the movie *Wallace and Gromit in the Curse of the Were-Rabbit* (above) was shot by holding the camera – with macro function enabled – firmly against the glass case of the display. This also allowed the use of the light of the display rather than resorting to flash lighting, which would probably have destroyed the mood of the photo.

QUICK TIPS 📷

✔ Don't get too close. Macro functions allow you to take photos really close up but there are limits. If you get in too close, you will end up with blurred results.

✔ Watch your shadow. When you get in close you, the camera and – especially – the lens itself can cast a shadow on the subject due to its proximity.

✔ Avoid using flash.

number 41

CAPTURE A GLORIOUS SUNSET

Few natural spectacles can rival a sunset for incredible colour and form. The best thing is that it's on display (almost) nightly - right on your doorstep.

▲ Including some silhouetted foreground interest can substantially improve the effectiveness of sunset (and sunrise) photos. You'll need to experiment a little with exposure (using AE-compensation or bracketing) to get the perfect result.

Don't put your camera away as the afternoon draws on - the best could be yet to come. Sunsets (and, of course, if you are an early riser, sunrise) are an absolute gift for the photographer. Never the same twice, the colours and shapes you get for those fleeting minutes can lead to some spectacular photos. So head outside and snap away, right?

Well, almost. Lots of people take photos of the most amazing sunsets and end up rather disappointed by the photos that they see later. Was their memory playing tricks with them? No. To get the best photos of sunsets you need to take control and employ a couple of tricks.

Underexpose
Camera technology works hard to produce photos that are perfectly exposed in every situation. This is a gift for the photographer because it lets us concentrate on what's in the viewfinder or on the LCD screen rather than worrying about the settings. But for sunsets, perfect exposures - in the camera's eyes - produce lacklustre effects. For the best colour, underexpose. Set your camera's exposure compensation to -1 stop. Or, for best results, try several settings and choose the best. Remember, you're not wasting film!

If your camera doesn't have exposure-compensation controls,

▼ Turn your back on the sunset and capture the landscape bathed in the rich warm light that's only there for moments prior to sunset.

#041

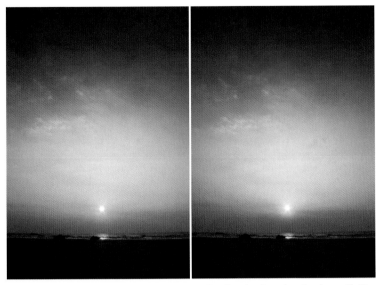

▲ Auto white balance sometimes adjusts for the dominant red colours (left). Switch to daylight balance and the colours are preserved (right).

▲ Small amounts of underexposure (negative AE-compensation) can substantially enhance the colour in your sunsets.

QUICK TIPS

✔ If using a neutral density filter, you may need to experiment with AE-compensation or manual exposure settings.

✔ Including landscape elements - buildings, trees, hills - can help the composition in a sunset shot.

✔ As a project, take shots of the same scene at sunset at different times of year. Even over a few days - weather permitting - you can get a wide range of contrasting sunset photos.

✔ Don't always face the setting (or rising) sun when taking your photos. Turn your back on the sun and you can get some terrific shots of the deeply coloured sunlight lighting the landscape around you.

✔ Use a tripod! Exposures lengthen as the sun sets and you could find your prize shots compromised by blur.

✔ Use the long end of your zoom (telephoto) to make the sun appear bigger in the frame.

don't worry. Try setting the flash control to 'flash always'. This will tend to underexpose the scene, but the flash will have little effect unless there is any part of the landscape in the near vicinity. Or you could invest in a neutral density filter. Place one of these over the lens and it will reduce the light coming through.

Control white balance
Just as your camera is adept at getting the exposure right so is it perfect for avoiding colour casts, thanks to the white balance control. Of course, at sunset you want to record the colour cast - that's what sunset photography is all about! The profiles of white balance controls vary from one camera to another, so you may need to experiment, but begin by shooting in auto mode. If this tends to reduce the red levels in your shots, select daylight. Or if you want to experiment, you could try some of the tungsten settings. The results are unpredictable, but can be intriguing!

WHAT YOU NEED

Software
Image-editing software if you want to enhance the colours

Hardware
Camera, neutral density filter (optional), tripod recommended

●✔●●● **Easy**
You need some experience of using white balance settings

number 42 EXPLORE A FLOODLIT CITY AT NIGHT

Rather like the winter, night is a signal to many of us to put our cameras away. That's something of a shame, as there are lots of photo opportunities beckoning as our cities darken.

As the sun goes down, familiar landscapes and cityscapes take on a new look as natural lighting is exchanged for artificial. We digital camera users – more so than our film-based equivalents – are ideally placed to capture this evolution into nightscape, as our cameras are pretty successful in faithfully recording the colours of the night. Here are some ideas for capturing a floodlit city at night.

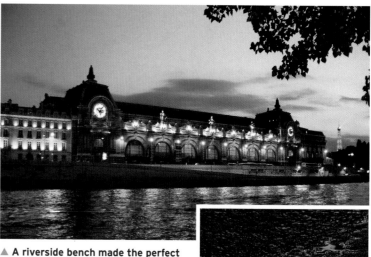

Don't wait till it gets dark

But aren't we talking about night photography here? Yes, but some shots – those featuring a lot of sky – work best when twilight is still illuminating the sky in pale cyan or indigo.

▲ **A riverside bench made the perfect mount for the camera to capture this sharp image.**

▼ **Taken just fifteen minutes apart, these two shots of the Eiffel Tower show how the last moments of twilight contribute to a much better and more colourful photo.**

Get a good grip ...

... or better still, some support. Exposures after dark needn't be very long, but are generally longer (obviously, perhaps) than in daylight. Make sure you hold your camera firmly to reduce shake or use an improvised support to hold the camera steady.

Look all around you

It's not just floodlit buildings that make for the most impressive shots. Shop windows, reflections in rivers and lakes, even passing traffic can make for intriguing shots. In the shot above, it is the neon lighting reflecting in rain puddles that produces colourful and fascinating imagery.

Experiment

Remember, with a digital camera, you don't burn film with every shot. Explore fully the possibilities that the cityscape has to offer.

SHOOT STAINED GLASS

number 43

It's been used for centuries to illuminate the interiors of religious and secular buildings. Stained glass can also produce some pretty stunning and colourful photos.

Unlike most photographic subjects that we record by virtue of the light reflected from them, stained glass, to show its true splendour, needs to be photographed with light shining through it. In most cases we will be on the inside taking shots of the glass lit by the sunlight outside.

Bright, overcast weather tends to be the best for shooting stained glass if you want an authentic record of the colour and design. Bright sunlight – and direct sunlight in particular – tends to cause uneven lighting and hotspots. But, when used creatively, these effects can produce fascinating photos – and even more so when the sunlight, coloured by the glass, shines on the floor. The result can be a glorious riot of colour.

Exposing for the glass

Getting the best colour from the glass depends on getting the exposure right. Often when composing a shot, the view will include some of the dark surroundings of the window – the church interior, for example. Your camera's metering system will try to strike a balance between the bright window and dim interior and produce a result that does justice to neither. It's better to get in close – or zoom in close – to ensure that the glass fills the

▲ Underexposing by 1EV retained the vivid colours of this slightly disturbing scene.

▼ Light shining on to hard surfaces through stained glass makes for an interesting shot in this office foyer.

frame. If necessary, underexpose by half or even 1 stop and check on the camera's LCD panel as to whether this helps better saturate the colours.

Look for details

A photo of a striking stained-glass window or a stained-glass rose can be very impressive, but often discrete details within the pane make for better results.

QUICK TIPS

✔ If you and your camera are exploring the city at night look out for stained glass in churches being illuminated from within. The effect is rather different from the daylight illumination.

✔ For interior shots, you will probably have to seek permission to shoot photos, particularly if you plan to use a tripod. In churches and other places of worship I tend to leave a small donation as a 'thank you'.

▼ Blessed with a bright interior, this view of a contemporary window in a medieval church was shot using automatic metering.

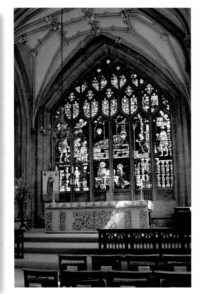

number 44

SHOOT STILL LIFE AT HOME

Shooting still lifes is a great way to experiment with your photography – and you will never run out of subjects to explore.

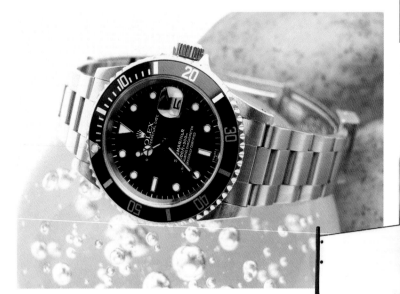

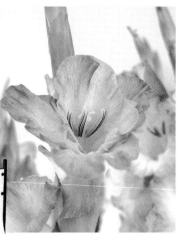

▲ **Strong, flat lighting from above and a clean white background produce very professional results.**

▲ **Diffused sunlight through a window is perfect for flat, almost shadowless, lighting. A copy table (left) makes this type of shot easy.**

Looking for something a little different to shoot? Cold or grey outside? Then maybe it's time to try your hand at studio-style still-life photography. It is surprisingly easy, and the results you can get with even the most simple set-up are more than worth the effort involved.

As with all types of photography, the key to still life is lighting, and, unless you're going to be investing in expensive studio equipment, you are pretty much stuck with what you've got.

So what do you need? Well, obviously a camera, and ideally a tripod for support. This makes it a lot easier to leave the camera in position while you fine-tune the elements in the scene or the lighting. You also need a table on which to place the items you are photographing,

▼ **Towards the end of the day, the more directional, warmer light coming through a window is perfect for shots such as this.**

and a backdrop. For this you can use anything from paper or card to a sheet or other material (dark velvet or fur, for example, are good at absorbing light for dark backgrounds). I would also recommend some bulldog clips or gaffer tape for holding it all in place.

As for lighting, you have two options. The easiest is to place everything near a window, and attempt to control how the light falls on the scene by whatever means you can – from partly

QUICK TIPS 📷

✔ Use a tripod to help avoid camera shake and to allow you to leave the camera in position whilst you tweak the set-up.

✔ For flat, subtle lighting, you need to wait for an overcast day. On sunny days, the best time to use daylight is early morning or late afternoon, and you won't get long.

✔ Artificial lighting is much more controllable. You can start by experimenting with household lamps (they should be the type you can angle to different positions). You'll need to use manual white balance if you don't want colour casts.

✔ The same rules of composition apply to still life as to any other type of photography – don't just plonk stuff on the table and expect to get attractive results.

✔ Turn off the flash; it will produce awful results.

✔ Zoom in a little – the wide end of the zoom won't produce attractive still life shots.

✔ Experiment with lighting, and take your time; don't expect to obtain perfect results straight away!

✔ Keep your still-life compositions simple, and make sure the various elements in the scene go together naturally.

🔍 ALSO SEE...

■ Discover macro photography – p.52

▲ **Small lights such as desk or bedside lamps are great for still life, but you need to experiment with your white balance settings to avoid colour casts.**

drawing the curtains to placing white card where it will reflect some of the light back into the shadows. The key, as always, is experimentation. I find the low

▼ **Often a black background is best for bringing out strong colours.**

▲ **The shafts of light coming through a window on a winter's morning make for dramatic lighting, but they don't stay around for long!**

light at the end of the day ideal – it's warm, and by part-drawing the curtains you can create dramatic shafts of light and position your still life so these shafts fall across it.

The subject matter is almost limitless. As the shots here show, you can find still-life subjects around the house, and as your expertise grows you can experiment with more ambitious compositions. You never know, you might end up buying all that studio equipment after all!

number **45**

SHOOT A STUDIO PORTRAIT WITHOUT A STUDIO

Creating a classy portrait at home is easy – even without any specialist equipment. All it takes is a bit of good light.

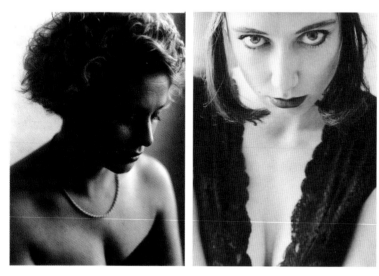

▲ Most cameras offer a black and white or sepia mode; try it for a classy portrait, or convert to monochrome later using an image-editing program, which offers better control. Both of these shots were lit by a single window.

WHAT YOU NEED ✓

Hardware
Digital camera, spare cards, tripod (recommended), plain background (white wall is fine), window

●●◖◌◌ **Easy**
This is all about practice

I don't really know many people who like having their picture taken. More specifically, I don't know many people who like the pictures that friends and family take of them. The reason most 'snaps' taken with compact cameras come out so badly comes down to two things: using on-camera flash, and using the wrong zoom setting.

Lighting
On-camera flash is never flattering; not only does it show every flaw and blemish, but the harsh directional light creates ugly shadows and the dreaded red-eye. Studio portrait photographers use large flash units on stands with special softbox attachments to diffuse the light. For the home studio, all you need is an overcast day. Place your subject by a large window, seated so they are facing slightly towards the light. This is all you need to do, though if the other side of their face looks too dark you might want to employ a sheet of card as a reflector to bounce some of the daylight back. Ideally, you should place your sitter in front of a neutral (preferably white) backdrop. A sheet taped to the wall behind them is perfect. Sit them in a dining chair or similar – it tends to promote better posture than a comfortable chair.

Zoom setting
The key thing here is not to use the wide end of the zoom. If you have a 3x zoom on your camera, step backwards and use the longest zoom setting. If your zoom is longer, aim for at least the half-way point. This will produce more flattering perspective – and

▼ Although a white background is the cleanest, don't worry if it is not – just go for something fairly neutral. Place your sitter as far away from the wall as possible and use a long lens and wide aperture to throw it out of focus.

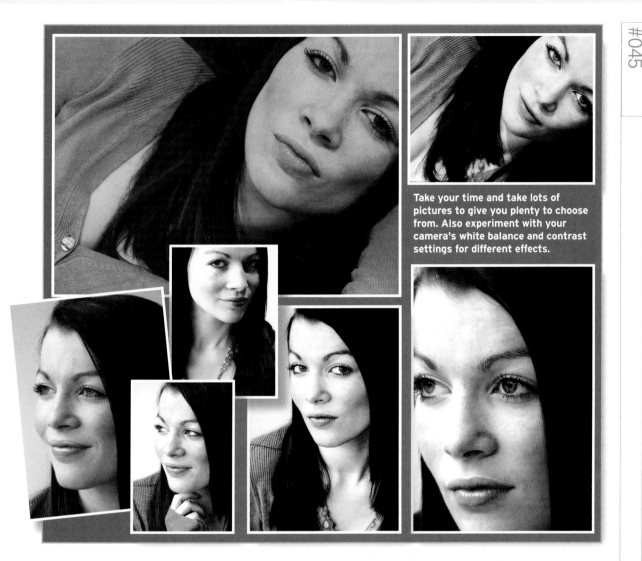

Take your time and take lots of pictures to give you plenty to choose from. Also experiment with your camera's white balance and contrast settings for different effects.

QUICK TIPS

✔ Don't rush, but don't take too long either! There's a fine line between taking long enough to relax someone, and taking so long they get bored.

✔ Remember the rule of thirds – don't put the eyes in the middle of the frame or the subject will look as if they're sitting on a very short-legged stool!

avoid the 'back of a spoon' effect of shooting with a wide lens.

Shooting tips
Unless your sitter is very confident, don't try to get them to pose for you, but do keep talking to them, and make suggestions as to where to position their head, and where to look. Keep the framing fairly tight – the face and neck are usually enough, but do experiment. Try to keep the camera roughly level with your subject's eyes (in other words, don't shoot from too far

above or below). And take lots and lots of shots, showing the results on the LCD screen every now and again as the shoot progresses. In my experience, it takes around an hour to capture a decent portrait (when both photographer and sitter will be more relaxed), and the best shots will be those taken near the end of the session.

Finally, always focus on the eyes (use focus locking), and - if you have the option - use the widest possible aperture (smallest f/ number) to minimize depth of field.

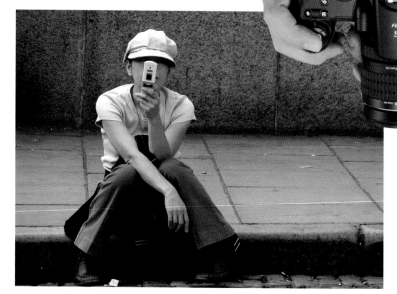

TRY YOUR HAND AT CANDID PHOTOGRAPHY

It can be a little nerve-wracking, and it certainly takes practice, but candid photography can also reap rich rewards, so why not have a go?

Candid photography encompasses all kinds of unposed, unplanned picture-taking, but most people associate it with a particular type of unobtrusive 'street' photography where the key to the success of the shot is that the subjects are unaware they are being photographed. This allows us to capture much more natural images of people as they go about their daily lives.

Candids represent the very essence of photography; a true 'slice of life', summing up in a frozen moment of time the everyday stories of human life. They can contain humour or sadness, stillness or frenetic activity, and the very best tell a story in a single picture. It's no coincidence that many of the world's most revered photographic artists made their names with candid documentary photography.

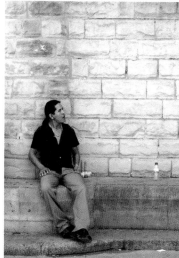

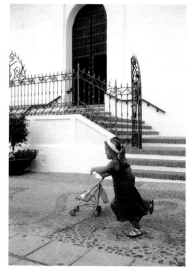

But candid photography is also challenging; it places spontaneity above technical considerations and it takes practice. First, you need to start to watch people and look for the right moment; the best candid photographers have almost superhuman powers of anticipation. You also need lightning-fast reactions, and you really do need to know your camera inside out, so the process of spotting the shot and taking it are fluid and intuitive. For this reason, compact 'point and shoot'

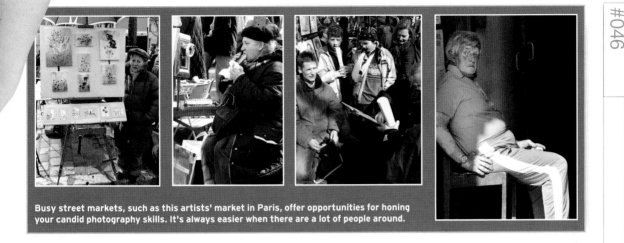

Busy street markets, such as this artists' market in Paris, offer opportunities for honing your candid photography skills. It's always easier when there are a lot of people around.

#046

cameras are ideal for candids - forget manual settings and just concentrate on getting the shot.

The other skill you need to learn is how to blend into the background; how to be unobtrusive. A tilting screen can be a really useful camera feature for candids, allowing you to shoot from the hip or at least avoid staring straight at your potential subject. Of course, a long zoom makes it a lot easier - and a lot less nerve-wracking - but don't rely exclusively on using a telephoto; if you move closer and use a wider lens, you'll get a shot that makes the viewer

feel as if they are actually 'in' the scene, and not merely spying on it from a distance.

Naturally, when you are photographing people without asking them there is always the risk of offence, so be careful - especially when travelling to areas with different cultures (in some parts of the world, you really need to do your homework). If anyone spots you pointing a camera at them and insists you stop, then stop! Some photographers like to approach their subjects and ask

permission before shooting; this takes some of the pressure off, but can also make less natural shots. My only advice on this would be to play it by ear.

So, the next time you go out with your camera, try your hand at grabbing a few candids - you will soon find you see great photo opportunities at every corner.

QUICK TIPS 📷

✔ Practise taking candid photographs of friends and family - the results will also make an interesting change from the usual posed shots.

✔ Look for people *doing* things, even if they are just staring into space. You'll soon develop an eye for what will make an interesting image, and can start improving your candids.

🔍 ALSO SEE...
■ **Shoot a character portrait - p.72**

number
47

TAKE YOUR CAMERA UNDERWATER

Whether it's sub-aqua explorations in the reefs of the Red Sea or a splash-around in a vacation villa, if you enjoy messing around in the water why not take your camera with you?

Some camera manufacturers are happy to demonstrate how waterproof their cameras are by displaying them under running water or submerged in a bowl. Even if your camera is one such model, we wouldn't recommend heading into even the shallowest of ponds with your camera unprotected! So if you want to get some great underwater shots, what should you do?

◀ A dedicated underwater housing ensures that you will get the best possible results. This model is for a compact digital camera, can be used down to 40m (130ft) and has an optical glass window for the lens.

It's in the bag
The simplest protection – but a solution that is remarkably effective – is the Aquapac. This is a heavy-duty clear plastic bag with an ingenious seal that ensures anything enclosed is kept completely dry. Drop in your camera, click the locks and you are ready to go. The soft clear

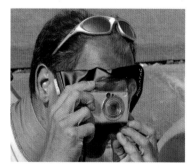

▲ Aquapacs are ideal for use underwater and are great for keeping sand and rain off your precious camera out of the water.

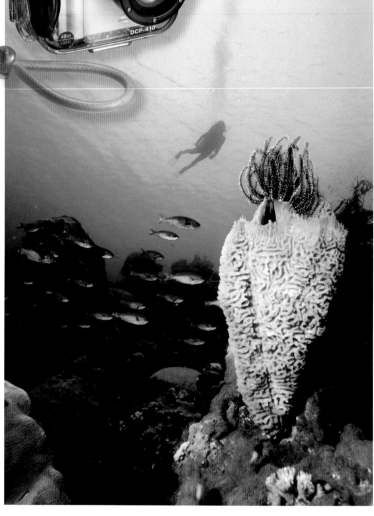

plastic ensures that you can view the camera's LCD panel and operate the controls.

The Aquapac also has the benefit that should you upgrade your camera, assuming that you don't trade up for a mega-sized model, you can use it just as

▼ **With a good underwater housing, shots like this are a cinch.**

effectively with the new model. Aquapacs are available for all sizes of cameras and also for mobile phones, GPS units and anything else that you might not want to get wet.

Getting serious
Aquapacs are very effective and surprisingly affordable, but the clarity of the plastic is not necessarily as great as optical

QUICK TIPS

✔ Resist firing the flash in an Aquapac. The flash light will reflect inside the bag and cause a whiteout.

✔ Try to load your camera into its underwater housing in the dry. This prevents fogging of the surfaces or the camera lens.

✔ Squeeze most of the air from an Aquapac before sealing – this prevents the bag being too buoyant and pulling you continuously to the surface. Don't worry – even with a little air, the bags are generally buoyant so if you do let go and don't have an armband attached, they will rise to the surface.

#047

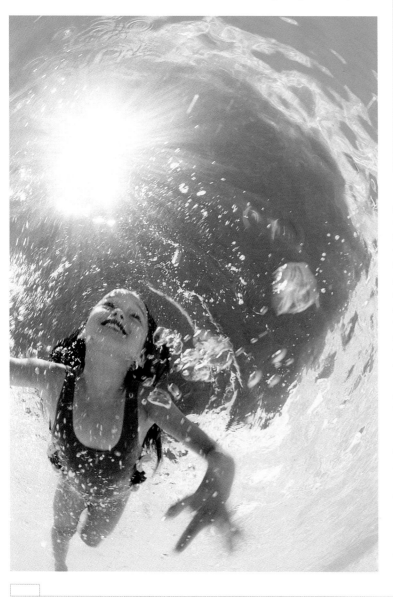

glass or some hard plastics. If you are serious about your underwater photography and want the best results, go for a dedicated underwater housing. These are rigid cases that are (of course) completely waterproof and have external control buttons that let you operate all the features of the camera. These dedicated housings tend to be much more expensive than the Aquapac, but do offer unrivalled quality. They will also allow you to operate the flash without problems.

Any drawbacks? Apart from the price, these housings are dedicated to specific camera models; if you change your camera, you need to change your housing – and not all camera models have a dedicated housing. So, if you are shopping for a new camera and you want to use it underwater, check availability first.

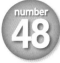

GET CREATIVE WITH LONG EXPOSURES

number **48**

Part of the magic of photography is how a long exposure can capture a drawn-out period of time in a single frame... and the results can be simply out of this world...

WHAT YOU NEED

Hardware
Digital camera with manual exposure or night or fireworks scene modes; sturdy tripod is essential

●●✔●● **Moderately easy**
Just keep the camera still!

Most of the pictures you take capture a fraction of a second of time and freeze it forever. The reason we tend to keep exposures so brief is simply to avoid blur, which happens when the camera - or something in the frame - moves whilst the shutter is open.

However, there are times when allowing some controlled blur into an image is desirable, usually because it allows us to capture some of the sense of motion into the image. There are also times, such as when shooting in very low light, when we simply can't use a fast shutter speed because it's too dark; at these times, the key thing is to keep the camera perfectly still so that camera shake doesn't blight the end result.

▼ **Here, a half-second exposure using a camera resting on a ledge captures some of the frenetic activity in a museum lobby.**

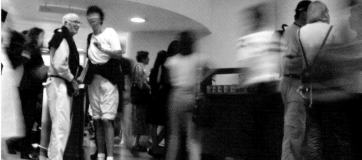

▲ **Long exposures are great for capturing moving water (such as waterfalls); the longer the shutter is open, the 'glassier' the water looks.**

Working with long exposures is challenging, but can be extremely rewarding, producing images that look ethereal and even slightly

#048

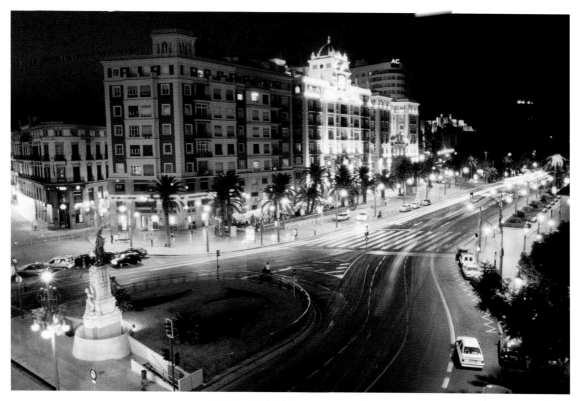

▲ **Exposures of several seconds allow you to capture the trails of car headlights on a busy city street.**

spooky, so different are they from the usual way we see the world.

Most digital cameras will automatically set shutter speeds down to as low as a second; a few require you to use special 'night scene' modes, and, of course, many offer full manual control over exposures, which is ideal.

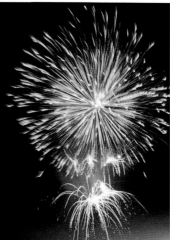

▲ **Fireworks need the shutter to be open for at least a second.**

◀ **Long exposures are virtually impossible without some stable support for the camera; a tripod is pretty essential.**

🔍 ALSO SEE...

■ Get to grips with shutter speeds – p.10

QUICK TIPS 📷

✔ Manually set the ISO/ sensitivity setting to its lowest (50 or 80 usually) for the best quality and longest exposures – and turn the flash off!

✔ If you can't manually control exposures, look for 'night scene' or 'fireworks' modes.

✔ Use a tripod and don't allow the camera to move at all during the exposure.

✔ Use the self-timer to avoid knocking the camera when you press the shutter.

✔ Experiment with different settings and check the results on screen. Take safety shots.

number 49 TRY YOUR HAND AT PANNING

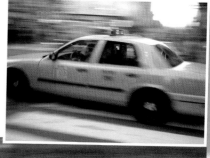

Panning is a professional effect that, with a little practice, anyone can master; the results can be fantastic.

Most people know that you can freeze fast-moving subjects using a high shutter speed, but what if you want to preserve some of the feeling of motion, or you simply can't use a very high shutter speed because there isn't enough light? Then it's time to try your hand at panning – a technique that requires a little practice, but can produce images with real excitement and a genuine sense of speed.

Panning involves using a fairly slow shutter speed – typically in the 1/5th to 1/50th range, although there are no hard-and-fast rules – while moving the camera to follow the motion

▼ Practise panning on moving vehicles; the slower the shutter speed, the more motion you'll catch.

of the subject you are shooting. The result – if you get it right – is to keep the subject sharp while blurring the background. Like most advanced photographic techniques, panning can seem

▲ The more accurately you follow the motion, the sharper the main (moving) subject will appear.

QUICK TIPS

✔ No matter how much you practise, handheld camera panning is always going to produce slightly unpredictable results, so take lots of shots.

✔ Pre-focus (half-press the shutter) before you start the exposure or the camera will miss the action altogether.

✔ If your camera doesn't offer shutter speed control, force it to use a slow speed by setting the ISO to its lowest, turn off the flash and zoom in as much as you can. You need to get your shutter speed to at least 1/30th of a second.

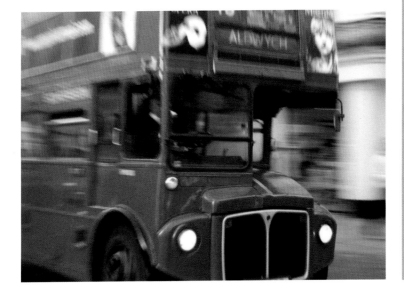

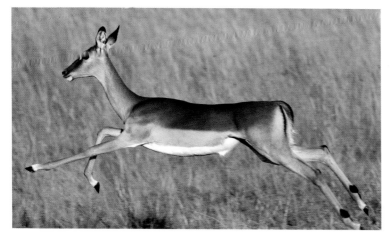

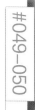

▲ Handheld panning is a bit of a hit-and-miss affair, but the results are often striking even when there is a lot of blur in the frame (here, the shutter speed was 1/20th second).

▲ A high shutter speed will freeze even the fastest motion; this gazelle was photographed from a moving jeep at 1/800th second.

very difficult at first, and involves no small amount of luck, but with practice you will find it coming naturally – and you will increase your hit rate considerably.

There are two basic panning techniques. The first one involves tracking a moving subject from a vehicle moving in the same direction at the same speed. This is actually the easier method. The first thing you need to do is

select a slowish shutter speed. If you can't control shutter speeds on your camera, set the ISO to its lowest setting and try the landscape mode if you have one – you need to be looking for a speed over 1/5th second but below 1/60th. Then you position the subject in the frame. It is a good idea to use burst/continuous mode to improve your chances of getting the perfect shot.

The second, and more commonly used, method is to track the motion of the subject by moving the camera to follow the motion in a left-to-right or right-to-left arc.

This technique is all about timing, and really does take some practice. The key is to start moving before you press the shutter, follow the motion (keeping the moving subject in the middle of the frame) and shoot as it passes in front of you. You need to avoid any vertical movement of the camera (which is why a tripod or monopod makes this technique a lot easier). The best technique is to stand with your feet apart to steady yourself, brace your elbows against your body and turn at the waist – this is one of the few photo techniques that lets you work on your love handles while you shoot!

number 50 USE BLUR FOR CREATIVE EFFECT

We spend most of our time trying to avoid blur in photographs, but as the tips on long exposures and panning show, there is a lot to be said for intentionally including blur in your shots.

Although the results are almost entirely unpredictable, shooting with intentional blur can produce very dynamic results, and is particularly well suited to cities

at night – the bright lights produce abstract trails of colour. Try rotating the camera as you shoot with a slow shutter speed, or point it out of the window of a moving car.

If you have a digital SLR (or a compact with a mechanical zoom), you can even try zooming during a long exposure. It's all a bit hit and miss, but every now and again you will capture a winning shot.

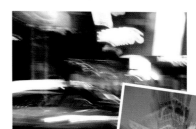

Using a slow shutter speed to allow blurring will sometimes produce successful results.

number **51**

EXAGGERATE PERSPECTIVE FOR DRAMA

In a tight corner, photographically speaking? When shooting in confined spaces, you can get dramatic effects through exaggerating, rather than trying to conceal, the effect of perspective.

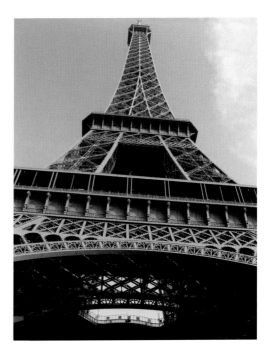

If you have tried your hand at architectural photography, you have probably come across the effects of perspective. Take a photo of the front of a building and you will see that the top of the building looks narrower than the base. This effect makes the building look as if it is leaning away from you. Or anyone looking at your photos might think you were leaning backwards, taking the shot!

Move into a more confined space where you have to point the camera upwards slightly, and the effects become more pronounced. It's a real problem. So what's the solution? One way around the problem is to tackle it straight-on – use the problem of perspective distortions to exaggerate the effect. Make tall buildings look even taller! This dodge is particularly useful – and often the only solution – where space is tight and you don't have the opportunity to step backwards to get a better view.

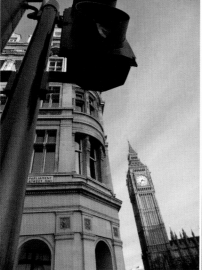

▲ ▶ Big monuments in confined spaces are difficult to capture without distortion, so why not emphasize the scale of something such as London's landmark Big Ben by getting low and creating a dynamic angle. Including some foreground detail like this adds to the effect.

▲▼ This technique need not be restricted to buildings. Here, it has been used above to capture the full glory of SS Cutty Sark's stern mast arrangement, and below to give a forest of winter trees a sense of menace and scale.

▲ Moving inside, and this time looking downward, can produce equally dramatic effects. Here is a dynamic shot of the central lift shaft at City Hall in Prague.

▲ You can add more drama, and make the composition of a shot better, by shooting the tall buildings diagonally, making best use of the photo frame.

 number **52**

SHOOT A CHARACTER PORTRAIT

Characters are all around us – recognize how to capture that likeness and get some great portraits.

You don't have to travel far to shoot character portraits. People with, if we can use the phrase in a photographic sense, 'interesting' faces are everywhere. The skill comes from being able to shoot them when they are at their ease and when their expressions are at their most natural.

The term 'character portrait' was originally applied to portraits of people that emphasized or caught the essence of their character. We could recall those famous portraits of 1950s movie stars that now make us immediately link the person with their most celebrated character roles.

▼ **Converting a portrait into black and white (use the Desaturate command to lose the colour in any image) can make a character portrait more intense, as we concentrate on tones on contrast rather than colour – perfect for gnarled faces.**

▲ **It's the slightly mischievous character of this jester that shines through in this character portrait.**

But character portraits don't have to be so earnest. We can find inspiration all around us. The grizzled face of an unhappy toddler, the moody stare of a teenager, the profound concentration of a musician

▼ **You can enhance a character portrait by cropping in closely, as we have here for this Elizabethan storyteller. The crop concentrates attention on the subject's face.**

▲ **The concentration of this violinist is apparent in this shot taken in mid-performance.**

– these are just a few ideas for starting off your character portrait portfolio.

What distinguishes a character portrait from a simple portrait? In a simple portrait, we generally try to make the best of the subject. Flattery is to the fore. For the character portrait, we can still be flattering, but we can go further and reveal something about the character of the subject too. Great character portraits don't come easily, but with a little luck, a little practice, and some good timing you will capture a lot more than a person's likeness.

🔍 **ALSO SEE...**
■ **Try your hand at candids – p.62**

number 53

SHOOT A THEME

Keen to get out with a camera but stumped for ideas? Try shooting to a theme.

There's nothing worse than being fired up to take some photos but, as you pass through the front door, being lost for inspiration. The fact that you can shoot absolutely anything with your camera can mean that you have too much choice and not enough, if you will pardon the pun, focus.

So here's a brilliant way to concentrate your mind on a photographic idea. Think of a theme. It can be anything:

a shape, colour or subject. Then go exploring, shooting photos based around that theme. Start with the obvious shots. If your theme is leaves, photograph some standard shots of leaves face-on, but then explore more abstract ideas. You might, in this example, go for backlit leaves, leaves in a stream or even (to go off at a bit of a tangent) leaves of paper.

The idea is to explore your subject. The result will be a

collection of photos that are all linked by the theme. In addition, exercises like this help hone your photographic skills and encourage you to move beyond the obvious when visualizing a subject.

What can you do with your themed photos afterwards? You could mount them individually and hang them together as a collection. Or why not print them all and mount them in a single frame, as a collage?

number 54 GET GREAT PHOTOS AT SHOWS AND CONCERTS

Whether it's the local amateur dramatics presentation or latest theatrical blockbuster, don't forget to take your camera along.

Theatre is all about spectacle and show. Sumptuous costumes, brightly coloured sets and lavish setpieces combine to produce an absolute gift for the photographer. So, how do you get the best photos of the performance?

First, choose your seats with care. You don't want your photos spoiled by the silhouettes of the spectators in the rows in front. Front rows on balconies, boxes and rows along gangways provide the best views.

Set your camera up in advance. The one thing you don't want to happen is for your camera's flash to fire along with every shot. Even at camera-friendly venues this will be a shortcut to the exit! Stage lighting in commercial venues tends to be bright, and you should be able to successfully handhold your camera.

Organizers of shows often ban photography. Sometimes this is for copyright reasons and is beyond the organizers' control. At other times, it is simply because of the number of automatic flashes that spoil the atmosphere for others and a blanket ban is the only way to successfully prevent this.

It may help to increase the sensitivity of the camera from its normal setting (usually described as ISO 100) to ISO 400 – or higher, if you have the option. This will allow faster exposures

▲ **Despite all the changes in colour and lighting, digital cameras can take them all in their stride.**

that are better at freezing the action. The camera's white balance is normally best set to auto to accommodate the wide range of lighting types that you will find in theatres.

Exposure times? Keep the camera set to auto – exposure systems will be quite capable of adapting to the changes in light levels.

Finally, shoot lots! If you have seen sports photographers at major events, they shoot hundreds – if not thousands – of photos during the event. Even with their professional eye,

▲ **Small local venues will often give you permission to photograph from very near the action.**

getting an image that captures a key part of the action with fantastic competitors' expressions is hard. Only by taking plenty of shots can they be sure of getting that elusive moment. Action in the theatre is rarely so fast-moving, but taking multiple shots is still good insurance.

QUICK TIPS 📷

✔ Do take notice of camera bans. Some venues are strict and will not allow you in with a camera; some have video camera bans; others are more laid back. If you really want to cover yourself, ask in advance whether cameras are permitted.

✔ Where lighting is less bright and action is fast, make the best of it. A slightly blurred dancer sweeping across a stage makes a great abstract shot.

number 55 EXPERIMENT WITH YOUR FLASH MODES

If you only ever use your camera's flash in fully automatic mode, it's really time you discovered fill and slow-sync flash...

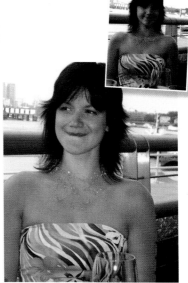

#054–055

We have mentioned elsewhere the many problems associated with the small built-in flash units on most compact cameras, from red-eye to lack of power. But we're stuck with it, so we may as well get the most out of what we have. The first step is to experiment with a couple of the more useful options on offer.

⚡ Fill (forced) flash

Your camera will by default fire the flash when it gets dark, but there are times when you might want to force the flash to fire even in bright conditions. The most common use is fill-flash, used to brighten the main subject of an image when the sun is behind it. Without flash, you would end up with the main subject in shadow – or in extreme cases, nothing more than a silhouette.

Using fill-flash is as simple as changing the flash mode from 'auto' to 'on'. You can now take the shot and the camera will sort out the balance of available and flash illumination.

⚡S Slow-sync flash

Fill-flash is there to solve a problem, but the other flash mode worth experimenting with is slow-sync. Normally, turning the flash on sets a fairly high shutter speed (around 1/60th sec). This is much too fast for the dim ambient light in the scene to register in the photograph, which is why flash shots lack

atmosphere. Slow-sync mode uses a slower shutter speed, and so allows some of the light already in the scene to record in the

▼ Fill-flash can avoid silhouetting when shooting subjects with the sun behind them.

▲ If the light behind your subject is brighter than the light on them, you will end up with their face in shadow. Fill-flash soon sorts things out!

photograph. The result is a sort of double exposure, with some sharp and some blurred areas, and it can be very effective. You just need to keep the camera still or you will get too much blurring. It is well worth experimenting!

▲ Slow-sync flash allows the dim light in the room to register on the sensor (so no black background), and produces an image with atmosphere.

◄ Slow-sync combined with panning is a tricky technique but the results are very impressive.

GET SOME GREAT PET PORTRAITS

number **56**

'Never work with children or animals.' Not the words of a photographer, but sobering ones nonetheless. Pets are an intrinsic part of many families and can make for terrific photos. If only they would learn how to behave...

x

WHAT YOU NEED

Hardware
For standard pet portraits, just a standard digital camera; a long (more than 3x) zoom is preferable for distance shots

●●✔●● **Moderately easy**
Mostly just camera technique

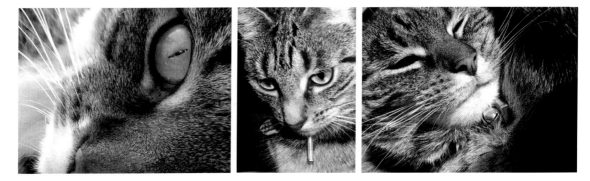

The techniques you have gleaned with regard to photographing people apply equally to photographing pets. We could encourage them into a formal pose displaying their best physical characteristics. Or we might prefer a more natural, candid approach, likely to bring their individual character to the fore. Here are the key tips to getting the best from your pets.

Learn patience
You will have to settle down for the long wait when you are photographing any sort of animal, and pets are no exception. Some animals, reptiles in particular, will respond to a cold stare; others will just look puzzled. There really is no alternative to patience. Have the camera ready for an instant grabbed shot.

Shoot lots
You are not burning up film so shoot away. The chances are that the best shot will come when you least expect it.

Bribe them with food
Pets are easily distracted. Posing for photographs is not in their psyche. But for many domestic pets, food (or their favourite

▲ **Get close, fill the frame and be patient and you'll avoid run-of-the-mill cat portraits.**

toy) is. A tempting treat is often enough to gain a pet's attention.

Position yourself
Pets do tend to respond to their owners, generally favourably! To capture a more natural portrait, keep your distance and use the camera's zoom lens to get in close. You'll also get better results if you lower your point of view to one that is closer to that of the pet.

▼ **No flash, but a bright room light was best to capture the detail in this much-loved insect.**

▼ **'Candid' portraits taken from a distance are often much more effective when the pet is distracted.**

QUICK TIPS 📷

✔ Remember that the same basic guidelines apply for pet portraits as when you are shooting the human members of your family.

✔ Cats are much easier to photograph when they are a bit sleepy, but try to get them to at least open their eyes!

✔ Get down to the animal's eye level - don't just shoot looking down on them.

✔ Use the long end of your zoom to capture more naturalistic 'candid' portraits.

✔ You need a high shutter speed if you're going to try to photograph an animal that won't sit still.

✔ It's easier to photograph a dog if you have an 'assistant' to keep it occupied.

▼ Get down to your pet's eye level for more appealing portraits.

NO PETS? NO PROBLEM!

If you haven't got a house full of animals, there are still plenty of ways to hone your skills. From parks to zoos to farms and county shows, you are never that far from a wildlife photo opportunity - especially during the summer. You will need a fairly big zoom unless you can get close, but at most zoos you will be surprised what you can get with even a basic model.

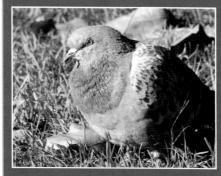

A walk in the country or the local park should give you lots of opportunities to photograph animals, and they will be quite used to human contact. Go on a bright day to make sure there's plenty of light - this will reduce camera shake.

Experiment with different viewpoints and zoom settings for something a little out of the ordinary.

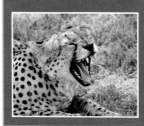

Zoos and safari parks make getting shots of more exotic animals fairly easy, though you'll need a big zoom for the best results.

Taking photographs from a standing position tends to lead to rather bland animal portraits.

Watch the glass
Shooting fish, reptiles or other animals kept behind glass needs special care. Because their homes are often indoors, there is a propensity for the flash to automatically fire when you shoot them. The results - a perfect portrait of your flash! Instead, turn the flash off and increase the camera's sensitivity to compensate.

🔍 ALSO SEE...

■ Take better pictures of children - p.78

number 57 TAKE BETTER PICTURES OF CHILDREN

Tough, but satisfying. That sums up photographing children. Tough because getting them to behave or play to the camera is well nigh impossible. Satisfying because the results will be treasured for a long time.

Children at play make great pictures. For more natural shots, hang back a little and 'zoom in' for a candid shot. Or why not turn the whole photo shoot into a game? (below).

You could take a formal portrait of your children, but be assured, you will have to take a lot of shots before you get that perfect, well-posed one. And then it will be more a case of luck than skill!

No, it's better to go for the candid portrait, taken when the child is oblivious to the camera. You will get more of the character of the child and catch them in their familiar surroundings. Also, because children tend to be easily distracted, even when they see the camera, a few seconds later you can be pretty certain that their attentions will be elsewhere.

▲ **It's generally best to get down to the child's eye level and to zoom in to fill the frame as much as possible...**

▼ **...on the other hand, breaking the rules will often produce striking (and quite funny) results.**

▲ **Don't forget the action shots!**

Here are some more tips for that perfect child portrait:

• Focus on the eyes. When you look at a portrait of any kind, the eyes of the subject are always where our attention is drawn.

▼ **Pets make great distractions.**

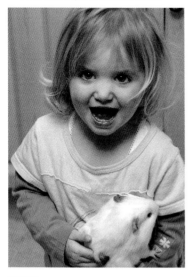

• Shoot from the child's level. Shooting from above can imply inferiority and makes the child look vulnerable. On the other hand, this can produce some great 'weren't you tiny' photographs.

• Shoot with the zoom lens set to telephoto – this will fill the frame with the child's face and help render the surroundings out of focus.

• Avoid bed and sleep times. The difficult becomes impossible when tiredness takes over.

• Shoot lots of images. You may think you have captured that perfect shot, but close inspection will show a blink, a frown or something else you didn't intend to catch. Taking lots of photographs reduces this risk!

• Use distractions: toys, books or – especially – pets are ideal for distracting a child's attention from the camera and elucidating some terrific expressions.

Don't just shoot lots at a photo session – shoot regularly, too. It's amazing how fast children grow and how little nuances appear in their character. It should go without saying, but that's perfect material for a photo album!

number **58**

TAKE CREATIVE CANDIDS AT WEDDINGS

Forget the stiff, clichéd album photos at a wedding and produce some authentic candids of the happy day.

🔍 **ALSO SEE...**
■ Liven up a wedding - p.24
■ Try your hand at candids - p.62

▼ **Make sure you've got lots of batteries and cards and just shoot all day. You can then share the pictures via the web or get a selection printed as a gift for the happy couple.**

become a family treasure. The formal photographs - even if they are taken in an informal style - don't necessarily give, with no pun intended, the whole picture. The true memories of the day come from the more informal episodes - the young children playing a game of tag precariously close to the wedding cake, snatched kisses with bridesmaids and

QUICK TIPS 📷

✔ Take care to respect any rulings when taking photos in places of worship.

✔ Shots of the top table at the reception don't just have to feature the speakers - often the expressions on family members' faces say more about the speech than words ever can!

✔ Bright days and acres of white satin can lead to underexposure of some shots. Tackle this problem by adding a +0.5 EV compensation. This should be just enough to stop the bride's and bridesmaids' dresses losing their sparkle.

Weddings, like holidays and vacations, are big photo opportunities. The appearance - all in one place - of friends and family, many of whom you may have lost touch with long ago, makes for great group shots and equally great memories.

The wedding photography itself is normally the preserve of a hired professional who will have discussed - usually at quite some length - exactly the type of photographs of the day the bride and groom want. The result is a beautiful album destined to

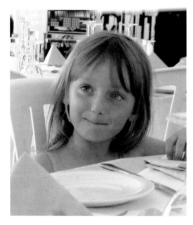

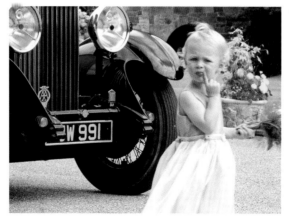

◀ **Children's expressions are usually a treat anytime, but at weddings they can be especially charming.**

distant uncles. Images like these – and many others – make a splendid counterpoint to the more formal photographs.

Weddings are a good time to capture candid images. So many people will have cameras that the guests will be less camera-shy and the chances of getting touching or intimate shots will be that much greater.

So how about creating a second album for the bride and groom, a complementary album to the official offering? Armed with your digital camera and not compromised by the limitations of film, you can shoot away all day long and choose the best selection for the album.

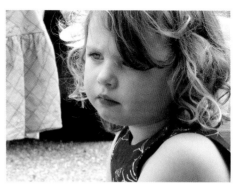

▼ **An evening disco is the perfect opportunity for some creative photography. Low lighting and long exposures give a dream-like appearance to photos.**

▼ **Grabbed shots like this – of two children taking a break from the festivities – can make for great memories.**

▼ **Candids of speeches can be particularly prized – especially if the comments are a little risqué!**

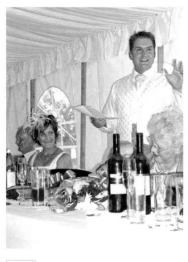

number 59
AVOID RED-EYE IN YOUR PORTRAITS

The best way to deal with red-eye is to prevent it happening in the first place. Here are a few tips.

Red-eye is the curse of compact cameras, turning even the most angelic subjects into demons. It's caused by the flash bouncing off the blood-rich retina at the back of the eye (the light comes too quickly for the iris to close down), and is worst in children, people with pale eyes and in low light (when the iris is wide open). Although there are plenty of easy ways to remove red-eye using software, it's always better – and easier – if you can avoid it in the first place.

Don't use flash
The simple answer to avoiding red-eye is to turn the flash off. Often light levels are high enough for the camera to take a good shot by the available light. You will get more atmospheric shots, but watch out for camera shake – you can check the results on the LCD and try again if necessary.

▼ **Using bounced flash (right) is the only sure way to guarantee no red-eye in flash shot. Direct flash (left) always presents the risk of red-eye, and is never very flattering. Some compact cameras offer the option to add a bounce flash unit (above); all digital SLRs have this option.**

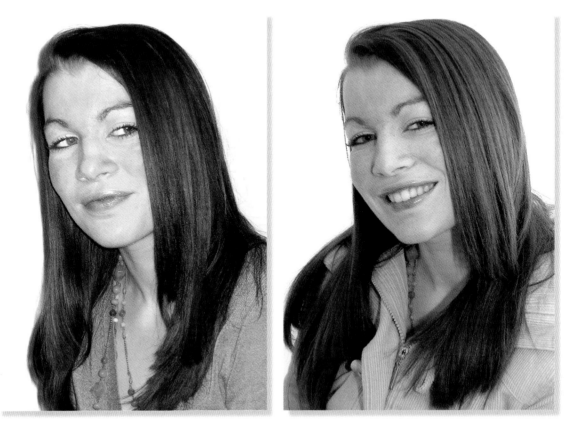

▼ Turning on the red-eye reduction mode will reduce the effect of red-eye, but not eliminate it.

Use red-eye reduction

It doesn't always work, but it's worth trying your camera's red-eye reduction flash mode, which uses a burst of light or a pre-flash to close down your subject's irises before the picture is taken, thus reducing the red-eye effect.

Move a bit closer

Although it might seem counterintuitive, you actually get more red-eye the further away you are from the subject. Obviously, there are disadvantages to this approach – wide-angle shots are rarely flattering.

Pose!

Red-eye is at its most obvious when shooting subjects face-on. Get your subjects to look to one side, look down or up and you'll lessen, or remove, the risk of

▲ Some manufacturers sell external flash units that even work on models with no flash connector.

red-eye. As a bonus, you will probably get some much more interesting photos, too!

Use external flash

Red-eye is due to the direct reflection of the flash from the eye. This is down to most cameras' flash units being too close to the lens. If you can use an external flashgun – which you can move further from the lens – you'll get better-lit shots and no red-eye. An external flash will also allow you to use a technique known as bounce flash. Angling the flashgun towards, say, the ceiling or a white wall will give a softer, diffuse light that's flattering in portraits and guaranteed to prevent red-eye. Some cameras have an external flash option, and even if they don't, you can often buy a third-party option; check with your local camera shop.

QUICK TIPS

✔ Red-eye is always worse when the subject's irises are wide open, something you will get if it's dark (or the subject has had a few drinks). One option when shooting flash portraits is to simply turn all the lights on to make the room brighter. I'm afraid you can't do much about the drink-related wide eyes...

✔ If you are buying a camera and would like to use external flash, make sure it has a hotshoe or other connector.

✔ Although turning the flash off might produce slightly blurred – or noisy – results, the pictures might still be a lot more attractive. Why not take two shots, one with and one without flash, so you can decide later?

▼ This candid shot catches the young karaoke singers looking at the lyrics on screen – avoiding the red-eye risk.

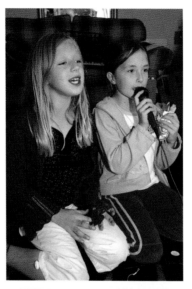

◀ Turning the flash off altogether will remove any risk of red-eye, but may result in some camera shake. Use a tripod and get your sitter to keep as still as possible!

🔍 ALSO SEE...

■ Give your camera some support – p.51

PHOTOGRAPH FLOWERS CREATIVELY

number 60

Flowers are one of the most photographed subjects in the world, and they're great for some creative experimentation!

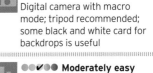
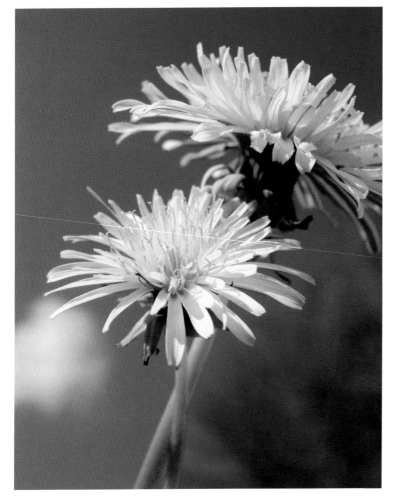

▲ A bright blue summer's sky makes a bright and cheerful backdrop for flowers - either bought or, as here, wild. Simply hold them up to the sky with one hand and take the picture with the other for an unique bug's-eye view.

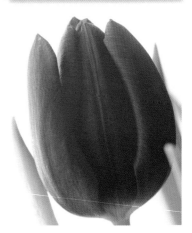

▲ Placing the flowers by a bright window, then overexposing (using +1.0 EV compensation, in this case) produces a vivid, studio-style study.

Flowers are one of the classic photographic subjects; they are a fairly inexpensive source of colour all year round, and they are very easy to photograph creatively with your digital camera.

The trouble is that being such a popular subject means that flower photography has become a bit of a cliché, and you have to try a little bit harder to produce something original.

Get close

Don't just plonk a vase of flowers on a table and shoot it; the results will be uninspiring, and the messy background will detract from the main focus of the shot. Frame the picture tightly to exclude as much as possible that doesn't need to be in the shot. Digital cameras excel at macro and close-up work, so make use of your camera's ability to focus in on the tiniest detail. You'll find a tripod a great help here, as the slightest movement when shooting close up will result in blur. And make sure you check the right part of the flower is in focus.

QUICK TIPS

✔ YOU can get a whole day's photography out of a single bunch of flowers – and brighten up your home – so it's money well spent!

✔ Don't buy mixed bunches – strong, single-coloured flowers such as lilies, tulips and roses make the best subjects for more creative shots.

✔ Use the lowest ISO setting you can for the best quality and to minimize depth of field.

✔ It can be difficult to get autofocus systems to focus on the end of the stamen, so take lots of pictures and check the screen.

✔ Of course, you don't need to buy flowers at all; there are plenty out in the wild.

▼ **Placing a black card behind this lily (lit by strong sunlight) was all that was necessary to remove a distracting background.**

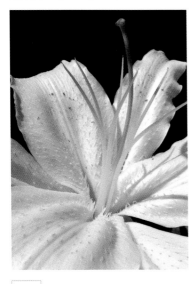

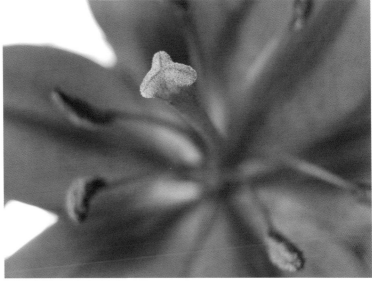

▲ **Digital cameras have excellent macro abilities, allowing you to focus in on the detail inside a flower. Watch your focus point and take lots of shots.**

Experiment

All the pictures on these pages were taken with simple 'point and shoot' cameras in the house or garden without any additional equipment save for a sheet of black card and a tripod. But you need to spend lots of time experimenting – and take lots of shots – to get similar results.

🔍 ALSO SEE...

■ **Discover macro photography – p.52**

 number **61**

SHOOT THE SEASONS: SPRING

Cameras – like much of our wildlife – instinctively come out of hibernation in the spring. As days lengthen, the skies shrug off the pale watercolours of winter and the colours enliven the landscape as flowers, blossom and early foliage appears.

Early spring is the best time to catch those flowers and plants that are first to brave the elements. Daffodils give a vivid splash of colour to a landscape that is otherwise still wintry in appearance. Snowdrops, appearing even earlier, look almost incongruous, blooming when there is still a strong likelihood of a carpet of snow. These make great photo opportunities both close up – in isolation – and carpeting the landscape.

Floral colour

Give spring a chance and the carpets of snowdrops give way to the other spring favourite, bluebells. These are great for shooting in their wooded glades, where the combination of light and shade can produce striking colour effects.

Spring is also the time for blossom. All too fleeting, the luxuriant pinks, whites and reds that adorn trees is one of the quintessential signs of spring.

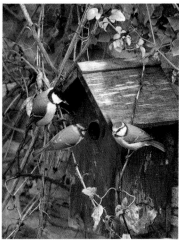

▲ **Spring is a good time to catch birds bagging nests. There could be a fight on here!**

▼ **Blossom brings some much-needed colour to the landscape.**

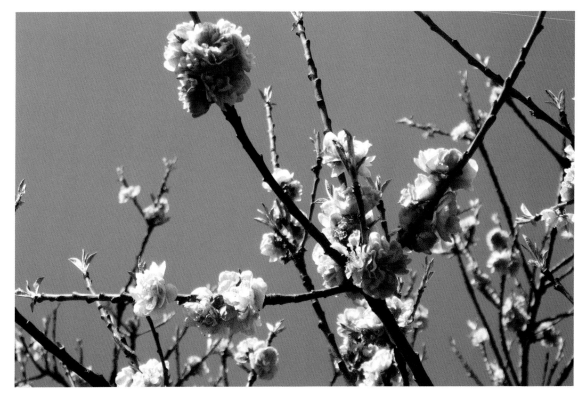

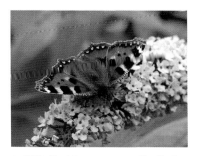

▲ With the blossom come the first butterflies and bumblebees.

Wildlife goes wild

Awakening fauna is a gift to photographers this time of year. The lower temperatures in the post-hibernation period tend to make many animals and insects somewhat more lethargic than normal and easier to shoot. Birds – those not brave enough to face the winter in our climes – reappear and begin staking a claim to nesting sites.

More than just eggs

Spring is also home to Easter. Apart from the usual parades, Easter egg hunts and other

▼ There's always something new – or old – to photograph at Easter.

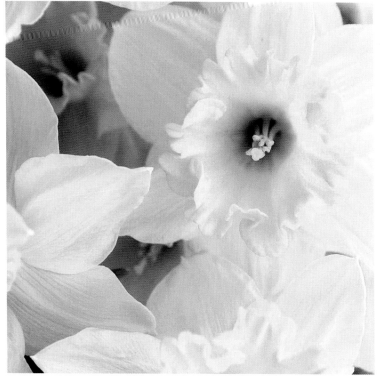

▲ Yellow is definitely the colour of spring, thanks to the daffodil.

events, Easter is also the time when many events that become commonplace in the summer begin. From fairs to military re-enactments to steam rallies and garden fetes, there's something colourful to photograph every weekend. Look at the 'What's On' pages in local newspapers and web pages for such events.

QUICK TIPS

✔ If your camera has been packed away for the last few months – probably since Christmas – make sure you've downloaded all the images from your memory card prior to clearing it for the new season.

✔ Encourage wildlife into your garden by putting out food. Animals tend to forage more at this time of year, and when they find sources of food they tend to return time after time.

number **62**

SHOOT THE SEASONS: SUMMER

Long days, blue skies, holidays, festivals... the list goes on. Summer was made for shooting lots of photos.

▲ The colours of summer – bright, vivid and deep.

▲ Holiday travel brings some terrific photo opportunities.

It should come as little surprise, but in the days of film-based cameras, 70 per cent of film sales were in the summer months, commensurate with the use of cameras. The picture – digitally speaking – is likely to be the same today. Summer is just bursting with colour; nature comes into its own, the good weather brings all kinds of outdoor events, and we set off on our holidays, cameras in hand. So is it just a matter of shooting away to our heart's content, confident in the knowledge that every shot will be a winner? Almost! Here are our hints for getting the best photos next summer.

Watch the sun

Not literally, but all that sunlight isn't all good news. The midday sun especially can be problematic to the photographer. Though bright, it tends to give very flat lighting due to the shadows and shading produced. Morning and afternoon give better results, and those long evenings give an extended chance for you to get some fantastic shots lit by the warm sunlight.

QUICK TIPS 📷

✔ Avoid having your subjects squinting at the camera when taking portraits by shooting with the sun behind them. To avoid the shot being in shadow, use some fill-flash. This will give enough flash light to counteract the shadows.

✔ Summer days are prone to haziness, especially when it's hot and humid. A polarizing filter can help to bring out the blue skies.

#062

▼ Summer sunlight can be a little hazy (bottom); towards the end of the day it is warmer and colours will appear deeper (below).

▲ All manner of things take to the sky each summer.

Watch the eyes!
Another reason to watch the sun is that it tends to cause anyone you're photographing to screw up their eyes. Avoid this by getting them to wear sunglasses, not face directly towards the sun or shoot a candid shot.

Holidays
Whether local or remote, holidays are a gift for the photographer. Remember to pack all you will need if travelling to exotic locations – you may not be able to pick up spare batteries or memory cards when you move off the main tourist routes. Think too about a storage device – a pocket hard disk-based unit – to allow you to shoot plenty of photos without paying regard to the capacity of your memory cards. Oh, and don't forget the chargers and the adaptors for the mains plugs!

Summer events
With the weather more likely to be favourable, summer is jam-packed with events, and you'll find photographic opportunities abound. Sports events, balloon fiestas, concerts and more make great subjects not only for photos but photo stories.

SHOOT THE SEASONS: AUTUMN

As the nights draw in, prepare your camera for nature's final colourful flourish.

As the summer holiday begins to become a memory, it's tempting to think the best photographic days are gone for the year.
In fact, as autumn progresses and the landscape takes on the characteristic colours, it's time to get outside and capture some terrific photos.

As we move towards winter, lighting changes almost daily as the sun gets lower and lower in the sky. In many ways, the lighting at this time of year is ideal. We have yet to reach the harsh, low level lighting of winter, poking

▲ Autumn photography isn't all about vibrant colour. Here it is the subtle seasonal mists swathing these conifers that is so expressive.

▲ Of course, cities are bathed in the same warm glow as the countryside at the end of a clear autumn day.

through the defoliated trees, and have lost the equally harsh midsummer sunlight. Here are just a few ways in which to exploit the autumn:

Go for colour
As deciduous trees shed their leaves, they go through a whole range of colours, from pale greens through yellows and reds. Think of the New England maple groves with their verdant colours – but elsewhere you will find many of the trees cloaked in mundane greens throughout the summer doing a pretty good emulation. Gardens, parks and arboreta with varied

▲ **What makes this a great autumnal shot? Is it the colour? The contrast with the coniferous trees? The mist? Or all three?**

▼ **Captured with gentle backlighting, the colour and shape of these acer leaves strongly suggest the essence of autumn.**

QUICK TIPS 📷

✔ Enhance the warm lighting of this time of year by shooting with your digital camera's white balance set to daylight. This will ensure the auto white balance controls don't filter out the delicate colours.

✔ Use the warm light of autumn to take flattering portraits. The gentle amber glow is great for skin tones.

✔ Get out at sunrise for the best light – and if you're lucky later in the season everything will come together – a touch of mist, low, warm light and the orange carpet of fallen leaves – for the perfect shot. Sunsets are also often very rewarding at this time of year.

✔ Get down and close to fallen leaves for some interesting studies in colour and texture.

✔ Look for landscapes with a mixture of deciduous and non-deciduous trees – this will give you a riotous combination of reds, yellows, oranges and greens – pick a day with a nice blue sky and you'll get beautiful, rich saturated images.

✔ Shadows get longer as winter draws nearer; use them to add depth to your pictures.

✔ It's not all about the countryside – the warm light at the end of an autumn day is also perfect for adding atmosphere to architectural shots and portraits. Be prepared though; the best light lasts only half an hour or so before sunset.

collections of trees and shrubs are great to visit at this time of year.

Watch the light
Throughout the year, the gentle warm light of sunrise and sunset is photogenic. In autumn it is even more so. The warm early – and late – rays of the sun, reflected from the carpet of red and brown leaves, produce a unique light that characterizes the time of year.

Take your landscapes by this light for rewarding photos.

Go for backlighting
In winter, we tend to get the best colour when shooting against the light – with the sun behind us. In autumn, you will get some great colours and almost liquid effects by shooting towards the sun. The sun shining through translucent leaves accentuates colour.

number
64

SHOOT THE SEASONS: WINTER

Don't let your camera hibernate the winter away. Drag it out and be rewarded with some great photos.

It's sad but true; too many of us put our cameras away after the summer and, apart from a modest flurry of activity around the end of the year, don't get them out until the temperatures rise again. That's something of a shame, because the winter can prove a remarkably photogenic time, even when the snow isn't crisp and even.

Here are some ideas for making the gloomiest of seasons into - photographically speaking - one of the brightest.

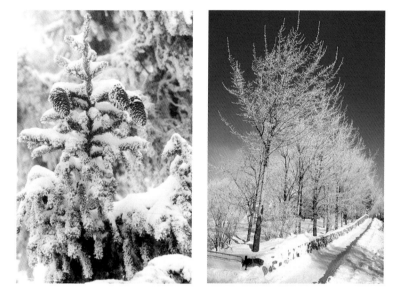

▲ Snow can be challenging to photograph - some manual intervention with exposure and white balance is often needed.

Watch the light
There's not much light in winter and the sun tends to be low in the sky. But this is just perfect for catching rays of light through defoliated trees and those long, powerful shadows. Because the sun is low for much of the time, the light can take on a warmth that we otherwise would only get shortly after sunrise and before sunset.

◄ Public events are far fewer and further apart during the winter, but they do provide a welcome bit of colour, so don't forget the camera!

▼ Winter photography isn't all about snowscapes and icy landscapes. Small-scale details such as these frosted fallen leaves also make great subjects.

▲ The warm light at the end of a clear winter's day provides a photographic goldmine.

QUICK TIPS 📷

✔ Though your camera may come to love winter, its batteries may not be so welcoming. Camera batteries tend to last shorter and shorter periods as the temperature drops. Make sure you carry at least one spare set and keep them warm in a pocket.

✔ If you adjust the exposure to shoot snow scenes, remember to return the setting to normal afterwards. Otherwise your standard shots will look rather washed out!

✔ Set your camera's white balance to daylight (rather than auto) if you find your snow shots taking on a bluish hue.

Exploit the weather

Crisp snow, hard frosts and leaden skies all offer different photographic opportunities. Even when the skies are grey you can get some great photos. Move in close and capture the details on holly trees or in the piles of leaves left over from the autumn. The lack of direct sunlight is ideal for casting shadowless light that is perfect for studies of details.

Snowfalls

Get out early when the snow has fallen. It doesn't take much – a slight thaw, traffic passing by or the inevitable children with improvised sledges – for the landscape to lose its crisp purity.

Adjust the exposure

When shooting snow or hard frosts, adjust the camera's exposure to shoot 1 stop more (overexposure) than you would otherwise. This is essential for ensuring the snow stays white (rather than grey) and the frosts are bright and punchy. If your camera doesn't have full manual control of the exposure, it may have a backlight compensation feature designed to prevent shadows in your subjects when shooting into the sun. Use this on your snow shots and you will get the same result as setting 1 stop or so overexposure.

The low down

When the sun is low in the sky, shoot with the sun behind you to get rich deep colours, but taking care with the shadows. Shooting towards the sun will produce hard silhouettes and an almost monochromatic view.

▼ Turning the camera into the sun produces contrasty images that have little colour but very powerful shape and form.

CHAPTER FIVE:
SOFTWARE PROJECTS

TAKING THE PICTURE IS JUST THE BEGINNING: IT'S TIME TO DISCOVER THE AMAZING WORLD OF IMAGE EDITING!

Whether you are simply tweaking the colour or producing a complex montage, the ability to quickly and easily alter a photograph in a million different ways is perhaps the most powerful by-product of the digital revolution.

Where once you were stuck with whatever appeared on the prints that came back from the chemist, now you have a world of software tools at your disposal for transforming your pictures at the push of a button.

In this final section, you will find a selection of ideas and techniques designed to give you a taste of what you can achieve very easily. Most require only the most basic computer skills and inexpensive software (I would recommend Adobe Photoshop Elements).

 The last few projects in the book (with this logo on them) are aimed at more advanced users. If you're not at that level yet, worry not; with a bit of practice (and some patience) you'll be able to follow the step-by-step instructions to create your own amazing works of digital art. Above all, you will find out just how much fun it is!

MASAI MARA 05

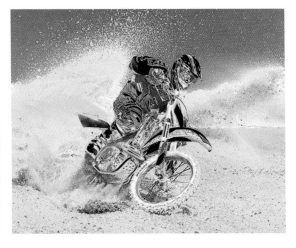

number 65

USE LENS FLARE CREATIVELY

Put a bit of real flair in your photos by judicious use of flare filters.

▶ **A sun-drenched view, with the sun high overhead and outside the limits of the photo. There is no flare in sight.**

It must be strange being a photographer involved in software design. Mindful that camera companies and lens manufacturers spend huge amounts of money devising optics that don't product reflections and flare, you then produce a software filter designed to put lens flare back onto what are otherwise perfect photographs!

Of course, there is method in this madness. Sometimes a photo can look flat when it doesn't have flare. Absurd though this may sound, we now readily associate lens flare with bright sunlight and a touch of flare can give added warmth to an image.

Flare filters emulate the flare you might expect from less than averagely corrected (for flare) lenses of different types. The exact choice will depend on which application you are using, but you can generally choose between a standard wide-angle lens, a zoom lens, and a telephoto. You may even have the choice of a movie-camera lens.

The effect from each reflects the optical complexity of the

◀ **Lens flare: 30mm prime – a modest amount of flare typical of wide-angle lenses.**

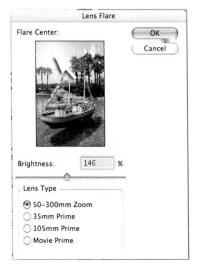

respective lens, with the zoom lens faring worst (i.e. producing most flare) because it has more lens elements around which reflection can take place.

To use the lens flare filter, select a lens type and an amount of flare (adjusted using a slider control). You also need to position the central point of the flare on the image – drag the flare point on the thumbnail in the filter's dialog box.

◀ **The flare dialog box (this is the one from Photoshop) has options for brightness and for the type of lens.**

QUICK TIPS

✔ As with all such effects, don't be too heavy-handed when applying. Too much flare can end up looking messy and fake.

✔ Pay attention to the shadows and lighting in your photos before applying lens flare effects. It's all too easy to place a bright source of light in the sky only to discover that shadows from the real sun are pointing in an entirely different direction!

▼ **Lens flare: 105mm prime – a simple flare pattern as would be generated by an optically simple 105mm portrait-type lens.**

▼ **Lens flare: zoom lens – by virtue of its optical complexity, the zoom flare option duplicates that lens's complex flare pattern.**

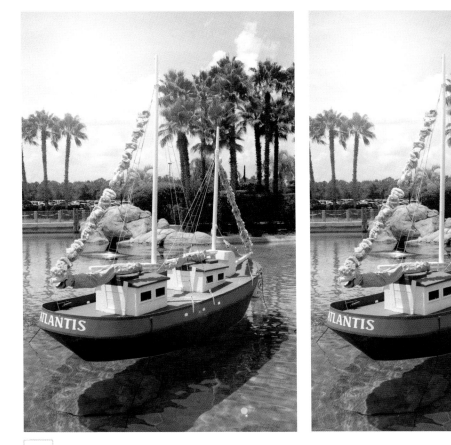

CREATE A WORK OF ART FOR THE LIVING ROOM

number 66

Super-size your favourite image to create a unique work of art for your living room wall.

WHAT YOU NEED ✓

Software
Image-editing application if you want to do any work on the image first; Internet connection if you choose to order online

◕◔◔◔◔ **Very easy**
The hard part is choosing the picture in the first place!

▲ **After careful selection of this colourful sunset scene, in the hands of a photolab it becomes a box-framed canvas triptych.**

If you have a photograph that is really meaningful or important to you – or you just enjoy looking at – why not make a really big copy and have it mounted as a unique work of art for your home? Most photolabs will produce prints as large as your budget will allow, and mount them too; all you have to do is find the perfect spot to hang it. But before you email that favourite photo, along with your credit-card details, here are some helpful hints for making

sure you end up with a print that you will love and treasure.

Choose the right image
Make sure your chosen image is a good one. This sounds obvious, but it is important not to be seduced by what you think is good, rather than what really is good. Get a second opinion, and try to visualize the photo blown up to a large size. You will be living with the results for some time! If you find it hard to visualize, you could always use the tips on page 34 to try it digitally first.

Check the quality
Printed to a large scale, any deficiencies in the original image

will be magnified accordingly. If your original is not pin-sharp, reject it. You will need a high-resolution image too. If your camera has fewer than 5 million pixels, stick with the smaller size prints. Or you could camouflage the pixel structure of the image by applying a special effect, such as a paint filter, grain or posterization.

Try a triptych
A large, simple photo can look even more impressive when presented as a triptych (a three-part image). You can either divide your image into three yourself, prior to ordering the prints, or let the photolab take care of the production for you.

Once you have decided on your photos, what's the best way to present them? Framing is the traditional way, but box-framed canvas prints are increasingly popular. Box-framed prints have the printed border of the canvas drawn around the sides of the frame to give a three-dimensional look. It is simple but effective.

🔍 ALSO SEE...
■ Create a posterized image – p.123
■ Solarize your photos – p.107
■ Create a quick work of art – p.110
■ Create a triptych – p.108
■ Redecorate your home – p.34

CREATE A JIGSAW FROM A PHOTO

number 67

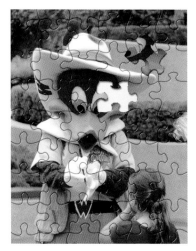

Got an aunt, uncle or grandparent who enjoys jigsaw puzzles? Well, why not give them a treat next birthday with a custom-made jigsaw? You can take any

photo and have it transformed - courtesy of your local photostore or online photolab - into a genuine board-mounted puzzle. Some labs will even give you a choice of complexities - simple puzzles with just a few pieces through to those that are somewhat more taxing.

Are there photos that make good puzzles? Yes. Bear in mind that it should be fun for people to do, so make sure that you choose a photograph that will be meaningful for the recipient and one that they will enjoy completing. Or let your mean streak show and go for a difficult subject. Remember those jigsaws forming a large image of baked beans? Why not think of your own, equally baffling subject?

QUICK TIP

✔ You can print your photos with a jigsaw pattern pre-printed onto them, thanks to a nifty little program from Alien Skin Software - Puzzle from Xenofex 2. You'll have to cut the pieces yourself, but we reckon the effect, which is compatible with Photoshop Elements and some versions of Paint Shop Pro, looks pretty good on its own anyway!

MAKE A CARTOON STORY

number 68

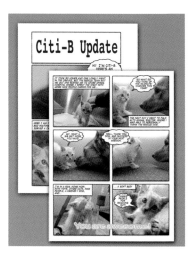

Ever fancied creating your own comic book? Or do you have relatives or pets whose antics are just crying out for the comic-strip treatment? Whether you want to create a comic or that staple of many a magazine, the photo story, here's the solution for you.

With just a little experience of image-editing software, you could produce your comic from scratch. It's not difficult, though it can be somewhat time-consuming. But there's a simpler way. Some image editors feature all the tools you need - templates, speech bubbles

WHAT YOU NEED

Software
Any image-editing application, although it's easier with an application such as Comic Life

●✔●●● **Easy**
If you buy the right software

and the like - ready to use. Or you can invest in an extra piece of software such as Comic Life from Freeverse (www.freeverse.com).

Armed with the right software, creating the photo story is simple; all you need are the photos to paste into the templates and a bit of imagination for the storyline. The example shown on this page was created in Comic Life by William Warrior.

number 69

COMBINE PHOTOS INTO A COLLAGE

A picture may well be worth a thousand words, but sometimes it takes more than one picture to tell a story, so why not combine several into a single collage?

From the trip of a lifetime to the first year of a baby's life, a well-produced collage will often add up to much more than the sum of its parts, so here's a quick guide to doing it yourself.

We're using Adobe Photoshop, but any program that supports layers (including many inexpensive image-editing applications) will be able to do the same thing. There are even some very cheap

shareware applications designed to produce collages automatically – although being based on preset templates, they don't offer much in the way of creative control.

WHAT YOU NEED ✓

Software
Image-editing application – this step by step features Adobe Photoshop

●●✔●● **Moderately easy**
You need to know how to use your image-editing program

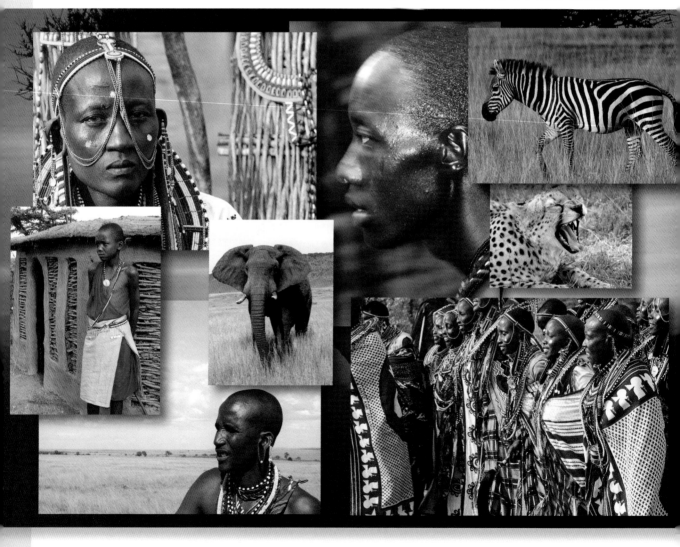

#690

[STEP 1]

Start by choosing a set of images from which you will produce your collage. Although you won't normally need more than about six or seven shots in a single composition, it's a useful exercise to draw up a slightly larger shortlist. If they are large (more than 2 megapixels), it's a good idea to resize them all to 1200 x 1600 pixels before you start.

[STEP 2]

Create a new blank document the size you want your final print. I used Photoshop and created an image at A4 size (8¼ x 11¾in), 300 dots per inch (dpi). You can use 200dpi if your computer isn't very powerful; it will print fine. Save the new file (in Photoshop format, or your application's native format). Don't close the window before the next step.

[STEP 3]

Open your pictures one at a time. Choose Edit > Select All, followed by Edit > Copy. Close the picture and go back to the main collage and choose Edit > Paste. This will add the picture as a new layer. Repeat for all your images. If they are too big, use Edit > Transform > Scale on each layer to reduce the size (hold down the shift key at the same time to scale without distortion).

[STEP 4]

You will now have a document with many layers; now is a good time to save the image again! Start to move the layers around (tip: turn on the Automatically Select Layers option for the move tool to save time), and delete those you decide not to use.

[STEP 5]

The simplest collage is often the most effective, and using a grid is an easy way of ensuring a clean look. Use Photoshop's guides to create a simple grid of rectangles and resize each layer to fit (see step 3 for how to scale them). Keep going until the page is full. Remember you can drag layers up and down in the Layers palette so they sit behind or in front of the other layers.

[STEP 6]

And there we are: a simple collage.

 MORE IDEAS FOR COLLAGES
number **69**

▲ Try adding white keylines with the pencil tool (hold down the shift key to draw straight lines); it can help if the images are all of a similar tone and colour.

▲ If you prefer something a little more dynamic, don't use a grid – experiment with overlapping layers, as here. Use the drop shadow option (under the Layer > Layer Style menu) to add depth to the collage.

◄ Try using a single, simple image (or even a plain colour or texture) as a background at the bottom of the layer stack for an even more colourful collage.

▼ If you want to try something really experimental, try using a soft-edged eraser (or layer masks if you are familiar with them) to remove parts of each layer and meld all the images into a single montage.

▼ Sometimes less is more, so combine a simple collage with a text layer. Don't be tempted to use zany typefaces and wild colours – the result will stand the test of time if you use a little restraint!

MASAI MARA 05

APPLY A 'QUICK FIX' TO YOUR PHOTOS

number 70

WHAT YOU NEED ✓

Software
Any image-editing application that offers a quick-fix option

✔●●●● **Very easy**
It's only one click!

Despite their prowess in so many areas, digital cameras often make compromises when recording a shot. The contrast in the image may end up a little compressed, the brightness range altered, or even some colours dulled. This is not serious, but is enough to take the edge off the shot.

Putting this right is a simple matter; it needs just a couple of mouse clicks. Your image-editing software has a useful little feature called Auto Enhance, Auto Fix or, depending on the application, Quick Fix. It has only one purpose – to ensure that any photo has the best range of brightness, best distribution of contrast and good colour. Try it on some holiday shots and see how much better they become, as with our before and after examples here.

QUICK TIPS 📷

✔ Sometimes (particularly if you have a shot with an unusual mixture of colours, such as a sunset) the auto fix command doesn't do a very good job; it will tend to alter the colour balance. Don't worry - try these alternative commands:

● Auto Brightness: this sorts out the brightness levels but doesn't affect contrast or colour.

● Auto Contrast: this fixes the contrast but leaves the brightness and the colour unchanged.

● Auto Colour: this sorts out just the colour.

number **71**

SHOOT AND STITCH A PANORAMA

With an ability to accommodate the widest landscape or interior, panoramic shots are spectacular. Creating them involves a little skill, but the effort will be well rewarded.

WHAT YOU NEED ✓

Software
Panorama stitching application

Hardware
Digital camera; tripod recommended

●●✔●● **Moderately easy**
The key is in the shooting

Creating a panorama is a two stage process. First, we need to shoot the separate component images that will comprise the eventual panorama. Then, we need to assemble these images to produce a seamless single image. Let's explore both of these stages.

Shooting the panorama
Once, panoramic photographers were equipped with specialized cameras capable of shooting, at the highest quality, photos that were many times as wide as they were high. Now, digital technology has made those cameras all but redundant. The same technology has made it possible for us, with our far less exotic equipment, ideally placed to create impressive panoramas ourselves.

Shooting the raw images that will be the basis of our panorama doesn't require any specialist equipment – just our standard digital camera. Set the camera's zoom lens to mid-range. This does not have to be exact; we try to avoid wide-angles because this can introduce distortions, particularly to the edges of our images, whereas long focal lengths, at the opposite end of the zoom range, tend to give too narrow a field of view.

If you can, mount your camera on a tripod. This will make it possible to be very precise when you are shooting the panoramic images. If you don't have a tripod, or don't have one to hand, don't worry – you will just need a steadier hand and more concentration!

Starting from the left-hand side of the panoramic view, start taking your photos. After each shot, move the camera around so that the overlap between the current shot and the previous is around 30 per cent. It may take quite a few shots to complete a broad panorama, but remember, you are not shooting on film, so you are not wasting any resources!

Assembling the panorama
We can now assemble these shots together to create our panorama. You can find software dedicated to panoramic photography or use a panorama-builder found in many image-editing applications. Photoshop and Photoshop Elements, for example, have a feature called Photomerge. That's the feature we'll be using here.

[STEP 1]

Import your images into the Photomerge feature. It's best to do this in sequence, as this will save time building the panorama later.

[STEP 2]

Let Photomerge build the panorama. Depending on the size of the original images, this may take a few minutes. Behind the scenes, Photomerge is identifying adjacent images and (thanks to the overlap we included) identifying common areas. It will then join together – or stitch, to use the correct terminology – the images into a seamless whole.

[STEP 3]

Even allowing for overlaps, sometimes the program can't identify common areas between images and so not all will necessarily be stitched together. Don't worry; you can manually place images in their correct order and, after being given this help, the images will be seen to snap together.

[STEP 4]

Once complete, you may need to fine-tune the panorama. Exposure differences between images can lead to brightness banding and unevenness, which might be particularly evident in areas of continuous tone, such as the sky. You can use the advanced blending button to resolve this. Once done, your panorama is complete and ready to print.

▼ **The more shots you take, the longer the panorama you can create!**

number 71 PANORAMA HINTS & TIPS

▲ **For professional-quality stitched panoramas you will need a tripod, and possibly a special panoramic tripod head that allows more accurate overlaps (left).**

QUICK TIPS

✔ You may need to trim the top and bottom of your panorama to get a smooth edge, especially if you have handheld your shots.

✔ Don't forget that you can create tall, narrow images or 'vertical panoramas' in exactly the same way.

✔ Some cameras feature an auto panorama builder that will stitch adjacent shots in-camera. Others have panorama modes that show a little of the previous image taken as an overlay to aid shooting the overlapping pictures. Check your camera's instruction manual.

✔ A tripod is essential for the best panoramas, as keeping the camera level is the key to making stitching easier and to avoiding too much cropping. If you get really serious, you can even buy panoramic tripod heads, with built-in spirit levels and rotating platforms marked with degrees to allow perfect overlaps.

✔ Shooting with the camera in the vertical (portrait) position produces a panorama with more in the frame vertically, but you need to take more shots to get the same 'width'.

PRINTING PANORAMAS

Panoramic photos are, by virtue of the fact that they are composed of multiple original images, of very high resolution. You can print them to large sizes and still get high-quality results. If you use a standard A4/Legal sized inkjet printer, you can purchase panoramic paper that has a conventional width but is up to 1m (3ft) in length - ideal for your prints.

Many online print services also offer panoramic prints at small or large sizes. These are perfect for making images to hang on a wall.

Don't forget that if you want to produce a panoramic print without doing all the stitching, you can always crop an existing image to the correct shape.

🔍 ALSO SEE...

■ **Create a Hockney joiner - p.137**
■ **Create a triptych - p.108**

72 SOLARIZE YOUR PHOTOS

number 72

If you want a truly bold, eye-catching effect for your photos, have a go at solarization.

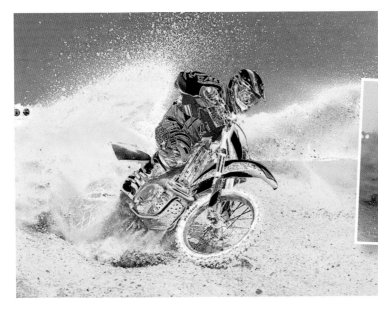

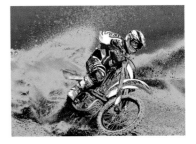

▲ Sports shots are a good candidate for the 'instant hit' of solarization.

This is one of those 'instant hit' effects – one click and you can see the result. Because of this, and because you don't have the control that some effects filters offer, you have to choose your source image carefully.

Stay away from portraits – unless you are after really wacky effects – and also landscapes, which tend to take on a post-apocalyptic look that has been, to be honest, overworked. The best subjects are townscapes and sports, as these benefit from the strong graphic approach. Unlike posterization, with which the effect is sometimes confused, solarization retains all the detail in a photo, instead reversing the colour and lightness in selected parts of the image.

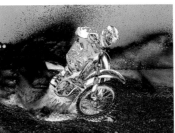

▲ Try inverting the image after solarization for a different effect.

Where do you find the solarize effect? It is usually nestled among the Filters. In Photoshop Elements, you will find it in the Stylize Filters submenu.

Why 'solarization'? The name comes from when the technique was used when processing film.

▲ Some applications offer variations on the basic solarization effect.

The effect would be achieved then by exposing the film to bright light (usually the sun) half-way through development. In those days, it was an unpredictable hit-and-miss effect. Some photographers' reputations could be measured by how successful they were in implementing it!

CREATE A TRIPTYCH FROM A SINGLE PHOTOGRAPH

number 73

The idea of the triptych goes back to Roman times, and has been popular in art since the Middle Ages.

WHAT YOU NEED

Software
Image-editing application; this step by step features Adobe Photoshop

●●✔●● **Moderately easy**
You need to know how to use your image-editing program

Got a large space on the wall to fill and only got an A4 printer? Worry not, this idea not only solves your problem, it creates an unusual and arresting result you'll be proud to hang in any room! For our example we're using Adobe Photoshop but you can create this effect easily in any software that allows cropping, though it's easier with a more advanced program.

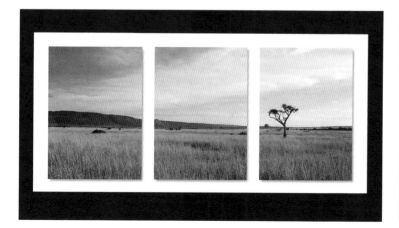

◀ For a really classy look, try converting the images to black and white. Also try mounting three small images (with a gap) in a single wide frame.

ALSO SEE...
■ Create a quick work of art – p.110
■ Redecorate your home – p.34

[STEP 1]

First, choose an image. You can start with any image, but landscapes without large features are the easiest to work with. Open the photo in your image-editing application. Do any colour or contrast corrections that you feel are necessary.

[STEP 2]

We now need to trim the top and bottom of the image to create a panoramic crop. If you know what size you want each print to be you'll need to work out exactly how wide it should be (for three A4/8¼ x 11¾in prints, it needs to be around 2.1 times wider than it is tall).

[STEP 3]

You now need to cut the image into three parts. Use the Image Size menu to see how many pixels wide your image is, then use a calculator to divide that number by three. In this case, my image is 1959 x 933 pixels, so I need each section to be 653 pixels wide and 933 pixels high.

[STEP 4]

You now need to set the dimensions. In Photoshop, you can set a selection to be an exact size, which makes cutting the image into three parts pretty simple. Click on the rectangular selection tool and in the Options bar (at the top of the screen) type in the dimensions you calculated in Step 3. If your image-editing application doesn't have this option, you will need to select each third by eye.

[STEP 5]

Now click on the image with the selection tool and one-third of the image will be selected automatically. Move the selection to the right side of the image (it will 'snap' to the edge). Choose Edit > Copy and then create a new blank document and choose Edit > Paste. You can now save this as a new file and repeat for the middle and left sections. Use the rulers to mark the edge of the first selection so you know where to move the box for the second selection. Do the same for the third one.

[STEP 6]

Now print each image at exactly the same size. Frame each one in a plain frame (or, for a really impressive result, have them printed onto canvas blocks), and hang them with a small gap in between each one.

CREATE A QUICK WORK OF ART FROM A PHOTO

number **74**

Creating oil paintings or watercolours in the digital world is a simple affair. All you need is a good photograph as a starting point.

For many users, the key part of image-editing software is the wide range of filters offered. In the same way that filters can be fitted to a camera lens to create special effects, so can these digital equivalents. But digital filters don't stop with just emulating conventional photographic effects – they can be used to create painterly effects. In fact, they can convert a photograph into a pastel print, oil painting, watercolour and a whole host of more abstract and experimental artworks.

The best thing about digital filters is that you don't need to be an artist to employ them successfully. Most can be applied to a photo with a single mouse click and, if the effect doesn't work first time, you can undo the effect and move on to the next. It is important to choose a filter that works well with an image.

Here are some samples. In each of these cases, we have simply applied a single filter effect without modification, or we have applied a single filter effect then finished off with a texture to make it look more convincing.

▶ **Crosshatch filter – this simulates dry-brush cross-strokes over an oil or acrylic painting. This works well with most types of subject.**

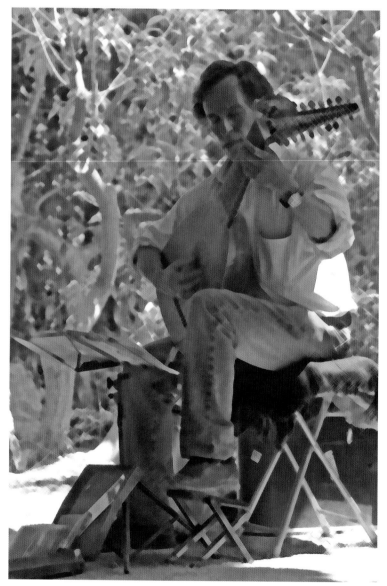

For a more modern look, try something geometrical such as this stained-glass effect.

The simpler the image, the better the end result (and the stronger the effect you can use). Here we've used Angled Strokes followed by a gentle Canvas texture to add some depth.

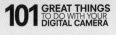

74 CREATE A QUICK WORK OF ART FROM A PHOTO

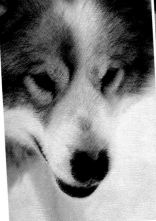

◀ ▲ The Rough Pastels filter creates the look of a pastel sketch on a regular canvas. This filter works well with rural landscapes and soft portraits. Note how printing the same image at a much reduced size hides the subtle strokes. This is why it's a good idea to resize your images before you apply any filters.

QUICK TIPS 📷

✔ There's an urge when we first discover the power of image-editing software to apply filters to each and every image. Sometimes we'll be moved to apply more than one to an image. The results are often jaw-dropping – but not necessarily for the right reasons. Use filters with care, and with consideration to the original image. We want them to enhance, rather than degrade the image.

✔ If you really get a taste for art effects, you can buy dedicated applications and add-ons (plug-ins) that offer much better effects than those built in to programs such as Photoshop.

Experimentation is the key; most art filters have sliders to control different parameters. Some settings will produce better results with some images; others with different types of pictures. If you find an effect you particularly like, it is worth making a note of the settings used.

One final thing to remember is that brush and texture effects are affected by the size of the image (in pixels) and by how large you print the end result. For example, if you have an 8-megapixel camera and you run a brush strokes filter on one of your photos, you need to set the brush size a lot larger than if you have a 2-megapixel camera. This means you need to remember to resize your image *before* you apply any filters; this is especially important if you are printing a multi-

▲ Most filters offer various sliders - try them out to see what gives the most convincing effect. Always preview effects at 100 per cent if you can.

For images you want to view on screen, you need to do the same - reduce them to screen size before you start.

▲ Fairly bold, graphic images lend themselves well to more graphic effects such as this - Chalk and Charcoal, followed by a Burlap texture.

megapixel image at a fairly small size. Use the application's Image Resize function to reduce the size to the correct dimensions at 200-300dpi, otherwise when you print all those fine brush strokes will be squashed down so small you can't see them.

▶ The Watercolour filter recreates the look of a watercolour painting. This is best suited to landscapes, rather than portraits or group shots.

CROP YOUR PHOTOS FOR IMPACT

number **75**

Cropping photos is a great way to make a good picture even better - and it's a simple skill to master.

WHAT YOU NEED ✓

Software
Even the simplest image-editing application will have a cropping tool

Very easy
It only takes a couple of clicks

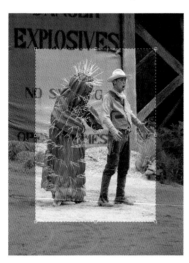

▲ The virtual cropping lines in image-editing software make it easy to precisely position the boundaries prior to cropping.

▶ The cropped image strips away superfluous and distracting parts of the original photo.

The more accomplished a photographer you become, the better you are at composing your photos - making sure the subject (or subjects) are placed in the best positions in your photos. But sometimes even the most seasoned pro doesn't get it quite right when they press the shutter, and often trimming away the edges of a photo can really make or break it. Selective cropping - the photographer's term for trimming - can improve composition and remove any

parts of the picture that might prove to be distracting.

Cropping cards
Before grabbing a pair of scissors, it can help to make a pair of cropping cards. These are simply

L-shaped pieces of card that you can lay over a print to visually crop the picture. This is ideal because it is non-invasive. If you don't like the crop, just reposition the cards. You can't do that with a pair of scissors!

▲ Cropping cards make it easy to visualize a cropped print without resorting to irreversible trimming.

▲ Cropping away some of the unwanted scenery in this wide-angle shot produces a more pleasing composition and concentrates attention on the main subject.

▼ Here a poorly composed shot has been improved immeasurably by careful cropping to put the main subject on one side of the frame.

Digital cropping

Using your favourite image-editing software it's possible to crop your images even before you get to the printing stage. Like the cropping cards, the crop tool places an overlay (normally by dimming the surrounding parts) across the photo, making it easy to judge the effectiveness of the crop. You can use the handles (the little squares around the edge of the central image) to adjust the shape of the crop to get the result just right.

When you are happy with your crop, hit the appropriate button to accept and the now superfluous surroundings will be trimmed away. Job done!

number 75 CROPPING FOR COMPOSITION

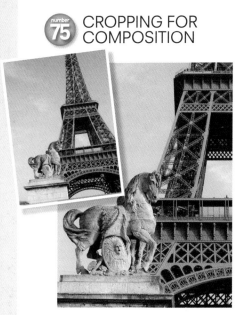

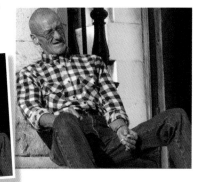

▲ Cropping will often reveal a good image lurking in even the most uninspiring photo. In the original, the tower looked cut off. Cropping to make the horse statue the main focus of the shot improves things hugely. Note that the image now has a pleasing diagonal, making a more dynamic composition.

▲ Try using the rule of thirds when cropping - it's amazing how much easier it is to think about the 'rules' of good composition after the picture has actually been taken!

▼ Often just tightening up the frame is enough to turn a mediocre shot into one with real impact.

QUICK TIPS

✔ Most of our photos tend to be rectangular, but don't be afraid to crop your images to a square shape if you like the result.

✔ Don't just trim your photos parallel to the print edges. Cropping at 30, 45 or even 60 degrees to the vertical can produce interesting images from otherwise bland photos.

✔ Save a copy of your original image prior to cropping - just in case you want to return to the uncropped version some time in the future. With the crop tool, there's no going back!

✔ Don't crop down to a very small part of the image unless you've started with a high-resolution image. A small trimmed image will often be disappointingly poor resolution when enlarged and printed.

🔍 ALSO SEE...

■ Use the rule of thirds - p.44
■ Composition basics - p.43

GET STRAIGHT!

One of the first lessons of photography - especially landscape photography - is that you should always check your horizons are actually horizontal. This is because the human brain is extremely adept at spotting even the slightest wonkiness in a photograph. Being out by one or two degrees is enough to ruin an otherwise pleasing image. Most software packages allow you to rotate an image before - or sometimes at the same time as - cropping. Since rotating a picture always results in the need for cropping (you lose some of the corners) it's a good idea to get the picture straight in the first place!

1 Experiment with unusual crops – here, I have cropped a portrait to remove half the face. Of course, you can also do this in-camera, but you would need a fairly long lens.

▼ Often only the slightest crop (and rotation, in this case) is needed to make a good shot perfect.

▼ Panoramic crops are a great way to deal with expanses of dull sky.

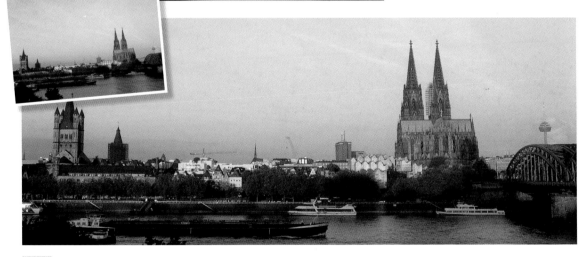

 number **76**

MAKE YOUR OWN GREETINGS CARD

Whether it's Christmas, a birthday or other celebration, a personal greetings card is so much better than a commercial alternative, so is there any excuse for not making your own?

Greetings cards are one of the best ways of showing off your photographic prowess and, at the same time, sending something very personal to friends and loved ones. Creating a greetings card needs very little work and just a touch of image-editing skill.
It doesn't really matter what event you are celebrating, the method is the same – so let's see how.

having a swinging time!

[STEP 1]

First we need to decide on the photo that will go on the front of the card. Choose something that's both bold and, if you want it to be particularly personal, meaningful. Make any edits – adjusting the colours, the brightness or the contrast until you are happy with the look.

[STEP 2]

Some cards won't need any explanation, but chances are you'll want to add some text: 'Happy Birthday', 'Best Wishes' - or something more imaginative. Remember, with a personalized card you don't have to stick to the tried and tested phrases! Text Effects makes standard text fonts more seasonal.

[STEP 3]

If you have an upright photo, you will need to print your photo on the right-hand side of the printing paper. This will allow you to fold the paper to produce a conventional card. How do you print on a selected part of the paper? Use the Print Options prior to printing. Often you will need to uncheck the box marked 'Centre Image' and drag the image to the right place. You can rescale to best fit the page at this point, too.

[STEP 4]

Print the inside of the card. If you want to add text to the inside of the card, repeat steps 2 and 3 to add an appropriate message. Print the inside, taking care, of course, to print on the right side of the paper!

▶ **Specialist software such as ArcSoft Greeting Card Creator automates the entire process.**

QUICK TIPS

✔ Don't feel you have to follow convention. You might want to print photographs on the front and back of the card and perhaps even more on the inside.

✔ If you are printing on the inside of the card make sure you use paper designed for double-sided printing. Otherwise you will get poor results when printing photos on the reverse, and a strong risk of smudging.

✔ There are even simpler ways of printing greetings cards - many image-editing applications have routines dedicated to cards of all shapes and sizes. You'll be prompted for the images to use, whether you want to add text, and that's it. Some applications will even print fold-line marks for you!

CREATE A PERSONALIZED CALENDAR

Want to have your favourite photos admired every day of the year? Then create a personalized calendar for friends and family.

Creating a calendar of personal photos – photos that are meaningful to the recipient – and one of professional quality is not only simple but also great fun. You can create your masterpiece on your computer and upload it to a professional photofinisher who will turn your creation into a unique gift for a modest – if not cheap – price.

You can find the template software needed to create calendars on the web or included as add-ons in some image-editing packages. Applications such as Photoshop Elements, for example, offer calendars via their Gift Store

▲ **First drag an image to the cover of your calendar and, if you wish, give it a title...**

(not available in all territories or all versions), as do some of the online photo printing companies.

Putting your calendar together is made simple by virtue of templates that allow you to drag and drop images from your photo collection directly onto the calendar. Optional page layouts let you choose a single photo per month or multiple images.

Depending on the template you use, you can even add visual cues to the day and date section of the calendar. So you could, for example, put your photo on your birthday so Auntie won't forget the date!

Once you have assembled your calendar, you can hit 'send' or 'purchase' and, after completing the necessary financial transactions, your

work goes off to be printed. Only days later it drops through your letterbox. The great thing about these is that – unlike those you may print yourself – they look totally professional. Auntie will be impressed!

▼ **...then drag and drop images to each of the monthly pages. Don't forget the specials for the birthdays, as shown here. Get to December and it's job done!**

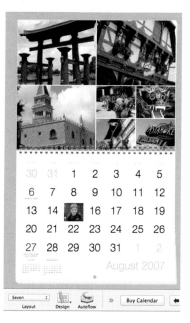

QUICK TIPS

✔ It's perhaps stating the obvious, but a calendar will be looked at almost daily, so think of the recipient when creating one. Make the photos included interesting and relevant. You want them to enjoy the gift every day.

✔ Edit or enhance your photos before committing them to the calendar. You want every photo to look its best. You may also find it useful to crop your images so that they will properly fit the space available in the template.

number 78

SHOOT SOME STILL-LIFE TEXTURES

Still-life photography used to mean shooting bowls of fruit in the manner of sixteenth-century painters, but take a look around and there are many more opportunities for some interesting photos.

QUICK TIPS

✔ Shoot some textures close up and from unusual angles. Presented as a slideshow on TV they make for a great identification game!

✔ Use macro mode.

Shooting textures and shapes is great when the weather - or other circumstances - don't allow you to take off with your camera to some photogenic venue. You can shoot a surprising range of fascinating and fun shots within your own home and garden. Shot close up, tree bark, wall surfaces and even rusting metal make great subjects for potent photos.

Take a look at the examples that are here. We've got a rusty metal plate, frost on a morning window, detergent bubbles, poster paint powders, magnetic letters and glass beads. Each image is simple but very effective. In combination, they make for great photographic displays on your wall.

PRODUCE A PHOTOTAPESTRY

Sometimes called a photomosaic in the commercial world, phototapestries are intriguing images. They are intriguing because, on close inspection, they reveal that they are composed of thousands of tiny thumbnail-sized photos.

▼ **Close inspection reveals the component thumbnails.**

You have probably seen phototapestries used in the advertising world, with a product shot composed of thumbnails representing aspects of that product, or in poster art, with famous artworks rendered by thumbnails of artworks by the same artist. Whether you regard the effect as clichéd or clever, there is no doubting the impact and these images certainly invite you to look more closely.

It's surprisingly easy to create a phototapestry, though you will need some specialized software - none of the major image-editing applications include this feature as standard. Take a look at the ArcSoft website for a good phototapestry application. The process of converting a photo into a phototapestry is straightforward. All you need do is specify the number of thumbnails you want to include. Clearly,

the more thumbnails, the more detailed the final image, but the more time it will take to construct. Applications such as that offered by ArcSoft include extensive galleries of thumbnails that can be used to create your phototapestry, but you also have the option of including your own gallery.

Including your own gallery opens up some interesting opportunities - you could, for example,

QUICK TIP

✔ Consider the size that you want your image printed to before setting the number of thumbnails. Too many thumbnails for the size of print will mean that the detail in them will be lost, along with the overall effect. Too few and the thumbnails, rather than the principal image, will dominate.

▲ **The more thumbnails you include, the more detailed the final image becomes.**

▲ **The closer you get to a phototapestry, the harder it becomes to distinguish the original image and the clearer the thumbnails become.**

produce a portrait of a loved one composed of thumbnails of that person at different ages and in different settings.

Once you have decided on the number of thumbnails and the images that will comprise those thumbnails, sit back and let the application take over. It will take a few minutes to build your finished phototapestry, but you can monitor the progress live. Once done, and it's ready to print and enjoy.

number 80 CREATE A POSTERIZED IMAGE

Here is a simple technique that converts standard photos into very powerful graphic images. It is called posterization because it recreates detailed, high-resolution photo as if it were made with poster paper.

Posterization reduces the number of colours in an image so that all those areas of similar colour (you can define how similar by setting a number of levels in the dialog box for the effect) are represented by a single tone. The more levels you enter, the greater the number of tones; the fewer you enter,

the fewer tones and, consequently, the more emboldened the image becomes.

Choose your images carefully when applying posterization effects. Suitable images are those with clear, bold subjects. Photos that are rich in fine, detailed content (such as landscapes) often tend to respond less well to posterization because the technique removes much of the necessary detail.

This action shot is an ideal candidate. The bold shapes are retained, as are the number of discrete colours. You can see from the example shown above why this technique has been called 'painting by numbers – with attitude'.

number 81

GIVE YOUR PHOTOS A FRAME/BORDER

Here's a way to save time and money on framing your photos – a way that lets you print the photo and its frame in one go.

Treasured photographs deserve to be seen and to be seen at their best means good presentation. Art stores and some photo stores offer special mounts and frames but, if you have a large collection of photographs to frame, the cost can be prohibitive. For most photos, though, simple framing is often better, allowing the image to take centre stage.

The simplest mount is called the keyline. This consists of a fine border around the photograph, which is itself set on a contrasting colour mount. Creating a keyline mount in your image-editing software saves the need for mounting boards and lets you print your photograph and the frame on a single sheet of paper. Here's how to carry out this process in three simple steps.

[STEP 1]

Open your image in your image-editing software. Use the Canvas Size command to increase the size of your photo. Add a very small amount to the width and the height – two to three millimetres is fine. Select black as the colour for the extended canvas (in some programs the canvas colour will be the currently defined 'background' colour). This adds a fine black keyline around the edge of the image.

[STEP 2]

Repeat the Canvas Size command, this time selecting white as the colour for the extended canvas. Add a larger amount to the size this time, around 20% of the original width and height of the image. Click OK to add the new border.

[STEP 3]

Photos with frames like this work really well in inexpensive clip frames. And you don't have to have a black keyline with white background. A white keyline and black background can enhance colours in some photos (as shown here). Experiment with other colour combinations too.

QUICK TIPS

✔ Make sure you select Canvas Size and not Image Size. When you increase the size using the Image Size command you enlarge the image itself to fill the new image size. Canvas Size, as we've seen above, adds new space to the photo.

✔ In Photoshop and Elements you can use the crop tool to extend the canvas – just drag the corners beyond the edge of the frame.

EASY BORDERS

If you like adding fancy borders and want an automatic solution, there are several inexpensive packages on the market, including ArcSoft PhotoPrinter, shown here.

OTHER FRAMING IDEAS

Once you've started to experiment with different frames, borders and edges, you will soon discover there is no end to the creative possibilities.

With practice, you'll also learn what works well with certain types of picture. All you need for most of the examples below is a simple image-editing application (or even better, one with automated framing options). The most important thing to remember is that any framing, edge or border you apply should enhance the photograph, not draw attention away from it. For this reason, simplicity is often the best approach – save the fake wood effects and fancy borders for greetings cards.

◀ ▲ **Edge effects, including soft vignettes, can add impact and interest to an image, but use them with care to avoid overwhelming the photograph itself.**

▼ **Using an altered copy of the image as a border can be very effective – and achieved using any application that supports multiple layers.**

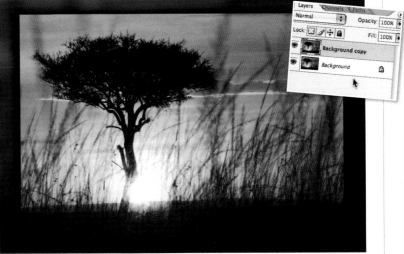

number 82

GIVE YOUR HOLIDAY PHOTOS A COLOUR BOOST

Make your photos look like a shot from the holiday brochures – and all with a couple of mouse clicks!

WHAT YOU NEED ✓

Software
Image-editing application with Hue/Saturation controls (virtually all have this)

✔●●●● **Very easy**
You'll need a very basic understanding of your program

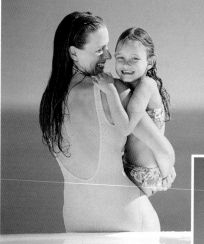

a little disappointed to find that your holiday photos were just a touch less vibrant?

Don't worry. Would you be surprised to hear that the holiday companies and photographers were

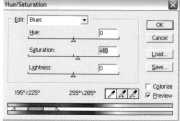

▲ The Hue/Saturation dialog box.

▶▲ **Hue/Saturation: before and after treatment.**

Vivid blue skies, azure seas and incessant sun. You'll see holiday brochures packed with photos displaying just those attributes. Be honest, wasn't it those pictures that helped to seal the deal on your next holiday destination? And weren't you just

saturation either of the entire image and all colours, or just a range of selected colours. You can also change the hue in just the same way. The hue slider is a useful control for altering sky colours – for example, making a pale blue-green sky look more intensely blue.

Here are some Hue/Saturation changes to give your holiday snaps that added punch.

QUICK TIP

✔ It's important with hue and saturation controls not to be too heavy-handed. Increase the saturation too much and the image will become oversaturated (move the slider to the extreme right, just to see the effect).

in cahoots in making their destinations seem more colourful and enticing? Probably not. So let's play them at their own game and add some more colour ourselves. You won't dupe the holiday companies, but you will certainly fool envious friends!

Our digital friend here is the Hue/Saturation command. With this you can boost the colour

- Increase the blue saturation by 10%.
- Increase the cyan saturation by 10%.
- Move the cyan slider 5% to the right.
- Add 5% to the green and yellow saturation.

Red is already a well-saturated colour in sunlit photos, so don't enhance it any more!

REDUCE THE REDNESS OF SUNBURNT SKIN

number 83

We've all done it; spent the first few days of our holiday basking in the sun, and the next few days nursing our burnt skin.

Burnt skin, bright light (especially flash at night) and the saturated colours of a modern digital camera can make for some spectacularly unflattering portraits. If your subjects look more lobster-like than sun-kissed, you can quickly fix the problem using any image-editing application that has Hue and

#082–084

WHAT YOU NEED

Software
Image-editing application with Hue/Saturation controls (virtually all have these)

●○○○○ **Very easy**
It's only a few clicks

Saturation controls. If only it was as easy to get rid of the real thing!

[STEP 1]

Start by opening your image and choosing the Hue/Saturation controls. From the Edit pop-up menu, choose Reds.

[STEP 2]

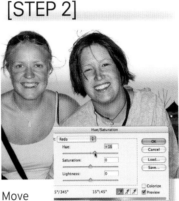

Move the hue slider slightly to the right until the red faces look browner (more yellow, basically).

[STEP 3]

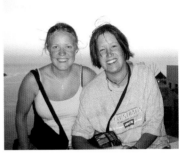

Finally, move the Saturation slider to the left until the skin tones no longer appear unnaturally bright. And there you have it – a two-minute makeover.

FIX RED-EYE IN A CLICK

number 84

▶ **Using a red-eye brush or tool cures the problem. From demon to angel in seconds!**

Do some of your people photos look a bit scary? Have angelic children or friends developed demonic red eyes? Don't worry, you are not alone! Red-eye is a common problem that, thankfully, is easily solved.

Fixing it
In the early days of digital imaging removing red-eye was a manual process, whereas now virtually all image-editing applications have automatic – or semi-automatic – red-eye removal tools.

Your image editor may have a red-eye brush, an adjustable brush that you can use to brush over the affected eyes. Others have a red-eye tool that you can use to select the affected area and – with a single keystroke – replace the red with black. The best thing is inexpensive, or even free, software (such as Apple's iPhoto, which is supplied with all new Macintosh computers) that offers this function. If your application doesn't, search the Internet for one that does!

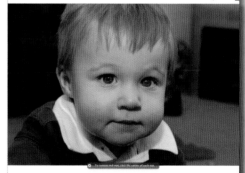

ALSO SEE...

■ Avoid red-eye – p.82
■ When to use your flash – p.17

number 85
CREATE A SOFT-FOCUS EFFECT

Soft-focus effects are fantastic for portraits, producing flattering skin tones and concealing minor blemishes. All that, and a romantic look too!

WHAT YOU NEED ✓

Software
Any image-editing application that offers layers and has a blur filter

✔●●●● **Very easy**
Mostly just one click

Professional photographers are armed with dozens of filters that, when placed over the lens, can be used to transform a good photograph into a great one. The rest of us prefer to travel light and, fortunately, we can achieve a similar effect digitally. To obtain our soft-focus effect, we will combine a pin-sharp image with a blurred version. Getting pleasing and effective soft-focus images depends on getting the balance between the two factors just right.

[STEP 1]

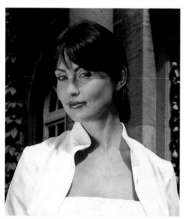

Open your image and create a duplicate layer. In most image-editing applications, you can do this by selecting Layer > Duplicate Layer. This is an exact copy of the original image. We can manipulate this and then combine it with the original.

[STEP 2]

To give the soft-focus effect, we need to blur this layer. Combined with the original image, this will give the original, sharp image the softness typical of soft-focus effects. Blur the image by using one of the blur filters. We're after a strong blur, so the best blur filter to use is the Gaussian Blur. Apply sufficient blurring so that there is no obvious detail in the image.

[STEP 3]

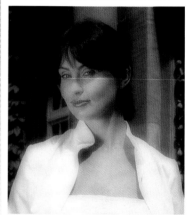

Reduce the opacity of the layer. This will allow the original image to appear through the layer. Depending on your subject, and depending on the amount of light and dark in the image, you will need to set the opacity of the layer (controlled by a slider on the Layers palette) between 40 and 70 per cent.

QUICK TIPS

✔ This technique is great for hiding fine lines and wrinkles in a strongly lit portrait.

✔ To restrict the softening effect to certain parts of the image (around the edges, for example), use a large, soft eraser (or mask if you know how) to remove parts of the top (blurred) layer.

✔ Experiment with layer blend modes to create some very different effects.

[STEP 4]

To give portraits an additional 'lift', you can change the blend modes in the image. Also, on the Layers palette you can select blending modes from the drop-down menu. Try selecting the Lighten or Screen blend modes. Each will give different effects.

▲ Soft focus shouldn't be reserved just for portraits. Try it on landscapes, particularly those that you would like to give a soft, dreamy look, or to imply a still, misty morning.

#085–086

number 86) PUT YOUR PHOTOS ON A CAKE

You can put your photos on a lot of things these days, but how about a birthday cake?

Children – and quite a few adults – like individual birthday cakes. It means something that is special for them on a day that is special. You could go to the local supermarket and, if your luck is in, find a cake that they would like, off the shelf. But why not make it extra-special by using some of your own photographic ideas?

▲ Here's an example for a boy whose twin loves – daleks and penguins – are never likely to be represented by off-the-shelf cakes. A quick bit of image editing however, and the graphic is ready to be printed.

Most cake shops and those bakeries that specialize in celebration cakes can take your photos and print them directly, using edible inks

▲ When the boy's birthday arrives, imagine his delight – and pride – at receiving this cake!

onto a thin film of icing. Then they can transfer the icing directly to adorn your chosen cake.

You can use just about anything as the original image, but our advice would be to go for a simple design: the resolution of the printers used to print the icing – and the texture of the icing itself – don't readily lend themselves to high-resolution printing. Go for bold graphics and simple designs.

QUICK TIP 📷

✔ Remember that many people are turned off by black and dark-coloured icing, so go easy on the strong colours!

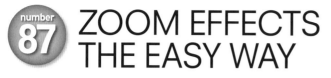

ZOOM EFFECTS THE EASY WAY

number 87

Here's a great technique for adding impact to action photos. It's one you often see professional sports photographers using to give their photos extra dynamism.

WHAT YOU NEED

Software
Any image-editing application that has zoom or radial blur filters (most do)

●○○○○ **Very easy**
Only takes a couple of clicks

Sports photography is a highly competitive business. Photographers vie with each other to get the best shots. One of their most impressive techniques is the zoom shot, so called because it involves operating the camera's zoom lens while taking the photo. It gives a remarkable sense of motion and focuses our attention on the subject – whether a footballer, cyclist or even a tennis racket. Getting it right requires skill and – dare I say it – a fair bit of luck.

You can use a simple bit of digital trickery and achieve the same result with any image from your digital photo collection. All it involves is the application of a digital zoom filter from your image-editing software.

Often you will find this filter in the Filters menu, under the Blur filters category. It will be called Radial Blur or, in some applications, Zoom Blur. Using it is simple. Open the image you want to zoom, move the centre point of the zoom to correspond with the centre of the subject in the image, and adjust the amount of zoom. Apply the effect.

Unlike some filters, you won't see the effect immediately on your image – it takes a few seconds to render – so you may not get the effect you were expecting first time. If this is the case, undo the effect and adjust the settings until you achieve the results you want.

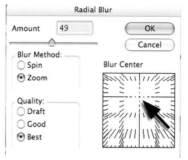

▲ The filter dialog box illustrates the amount of zoom (controlled by the slider) and allows you to reposition the centre point of the zoom using your cursor.

QUICK TIPS

✔ Learn to use the controls of the filter to get the zoom effect just right. Too little zoom effect gives an image that appears just blurred; too much creates an effect much like speeding though a narrow tunnel.

✔ Apply the filter to photos of the front of a car for an dynamic motion effect – far safer than taking the shot for real!

✔ Zoom filters often have different quality settings. Use the low-quality setting to test the effect (this is applied to the image very quickly) and when happy with the result repeat using the slower, high-quality setting.

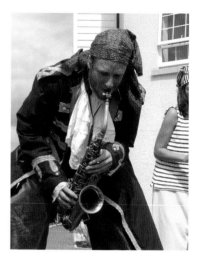

▲ We can apply the zoom effect to this photo of a street musician and concentrate attention to his head and hands.

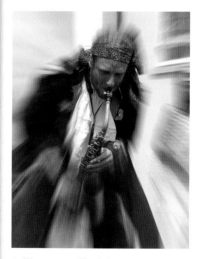

▲ The zoom effect draws our eye to the musician's face and hands and, usefully, blurs the distractions in the background.

CREATE CUTOUTS FOR POWERPOINT

number **88**

WHAT YOU NEED ✔

Software
Photoshop, Photoshop Elements or similar; presentation software such as PowerPoint

●●●●●❂ **Advanced**
Requires image-editing skills

Anyone who has ever attempted to use images with transparent areas in a PowerPoint presentation will have soon realized that it isn't as easy as you might think.

Although PowerPoint offers basic cutout tools (the ability to pick a colour from the image to be transparent), this rarely produces the result you are looking for. But there is a foolproof way using Photoshop or Photoshop Elements to ensure your images arrive in PowerPoint without a white background; it's all down to the file format you use to save the picture.

[STEP 1]

Start off by cutting the background out of your image. Double-click on the background layer in the Layers palette to make it editable and delete the background using whichever tools are most suitable. Here, I used the Magnetic Lasso to draw around the car, inverted the selection and pressed delete. When you've deleted the entire background choose Edit > Save for Web...

[STEP 2]

When the Save for Web dialog appears, click on the Optimized tab (if it is not already selected) and choose PNG-24 in the Settings menu. Make sure you check the Transparency option and click Save. PNG is an increasingly popular web file format that, like GIF, supports transparency but, unlike GIF, offers full 24-bit colour.

[STEP 3]

Open your PowerPoint presentation and choose Insert > Picture from File (the exact menu item may be different according to your version and platform) and find the PNG file you created in step 2. The image will appear as a cutout without a white background. Don't worry too much if the edges look a little jagged; in presentation mode, it will look perfect.

ADVANCED USER TIP: SOFT DROP SHADOWS

PowerPoint cannot produce soft-edged semi-transparent drop shadows on its own. For a really professional result, you will need to prepare your images complete with their own drop shadows.

The secret is to use a plain slide background in PowerPoint - as long as the background colour of the image that you create is identical, the join will be seamless.

Choose a custom slide background colour in PowerPoint. If you can, choose a colour using the web palette rather than RGB values (PowerPoint and Photoshop have different ways of measuring RGB values). Make a note of the colour chosen. Open your image in Photoshop, create a new layer below your cutout, and fill with the same colour. Add a drop shadow to the cutout layer in the usual way. Flatten the image and save it as a JPEG for importing into PowerPoint.

 number 89

CREATE A QUICK CARICATURE

With basic image-editing skills – and a bit of a cruel streak – you can have endless fun with friends, family or colleagues!

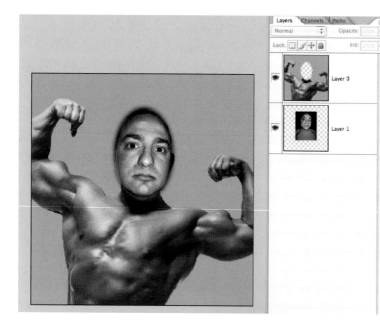

◀ **All these examples use two layers. You can either place the new body in the top layer (as here) and cut a hole for the face to show through,** or cut the face out of one image and paste it onto the new body (right). In either case, you will probably have to scale the face layer to fit, and adjust colour and brightness to get a better match.

Photo caricatures are a fun way to show off your digital imaging skills, and make perfect images for birthday, retirement or leaving cards – but make sure you don't go so far your 'victim' takes offence!

The easiest way to produce a quick caricature – and the one used for most of the examples here – is the old 'swap the head' trick, though we are actually only swapping the face. The secret here isn't to produce something too convincing, but to produce something funny, so don't worry too much about how well you blend the head and its new body!

If you don't have any funny pictures to put your friends' heads onto, try

▼ **Images found on the Internet can be quickly cut out and added to a face for a funny birthday card.**

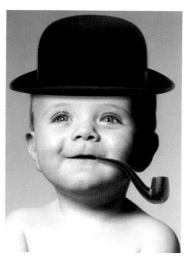

using Google's image search facility – you won't get anything very high resolution, but it will be fine for a joke picture on a card. Alternatively, try one of the many royalty-free stock image sites on the Internet. Bear in mind that images found on the Internet may be subject to copyright, but as long as you are only printing the image to put on a card (i.e. not sending it via email or publishing it), you are unlikely to face any problems.

The techniques are simple, and involve little more than cutting out a face from one image and pasting it onto another. You'll need to know the basics of working with layers (so you can resize the face to fit and adjust the colour to match), but as I said, this isn't about producing convincing results, it's about making people smile!

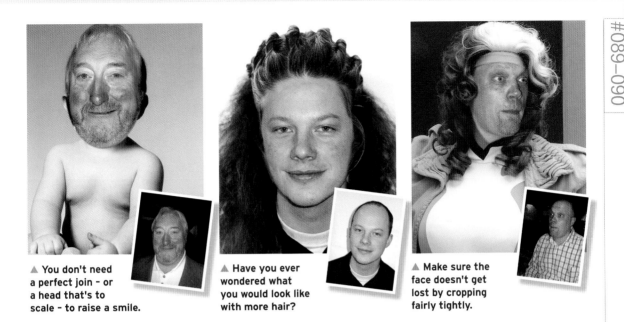

▲ You don't need
a perfect join - or
a head that's to
scale - to raise a smile.

▲ Have you ever
wondered what
you would look like
with more hair?

▲ Make sure the
face doesn't get
lost by cropping
fairly tightly.

number 90 TURN WHITE SKIES BLUE!

On overcast days, there can be
plenty of light around, but the
white skies and lack of bright
colours in general are a washout,
photographically speaking.
Traditionally, photographers would
attempt to salvage the situation
by attaching a graduated tint filter
to the front of the lens. This might
not produce a very realistic image,
but it certainly produces a more
attractive one.

▼ Overcast days produce white skies
that are not very attractive.

▲ In your image-editing application,
add a new blank layer and use the
gradient tool to create a gradient
from blue to white that covers most
of the sky area. Change the blend
mode of the new layer to Darken. You
can now experiment with different
layer opacities (or change the colour
of the gradient if you want).

You can still buy graduated tint
filters, but with a basic image-
editing application (that supports
layers) you don't need one; all it
takes is a few mouse clicks. The
digital advantage is that you can
choose whatever colour you want
for the tint, and save as many
versions of the picture as you like!

▲ It's a good idea to brighten up
the image a little by increasing the
saturation of the main photograph.
And there you have it - a two-minute
blue sky.

▲ Another popular filter in the
days before digital was a tobacco
graduated tint, which gives an
evening-time feeling to a shot.

TRY YOUR HAND AT BLACK AND WHITE

number **91**

No matter how popular colour photography is, there will always be a place for the classic black and white print, with its timeless quality and sheer class.

▲▼ **Choosing the right image for a black and white conversion is half the trick. The shot above is boring as a colour photo, but in black and white the texture and form are much stronger. The subject of the picture below immediately suggested the black and white treatment.**

Of course, at one time black and white was the only option for photographers. But despite the arrival of easy colour photography over half a century ago, people are still drawn to the classic and timeless appeal of the monochrome print. Virtually all cameras have a dedicated black and white mode, but there

◀ **Leaving part of an image in colour (using two layers) draws attention to the main subject, and in this shot, increases the sense of isolation.**

is that there are many ways to convert from colour to black and white using image-editing software, many of which produce better results. This means that as your experience grows you can experiment with more advanced conversion processes.

Monochrome magic

As well as producing classy images, working in black and white (or greyscale, as it's known in digital imaging) can make life a lot easier for the novice image manipulator.

are a couple of good reasons not to use it. First and foremost is that it lets you keep your options open; shooting in colour allows you to convert to black and white in a single click without losing

the original colour version of the photo. Shooting in black and white means you will never be able to produce a colour print from the photographs you take, even if you want to. The second reason

You will find that not having to worry about colour means you can more easily remove distracting objects or whole backgrounds from shots, and you can play with more extreme contrast and texture effects. Just as the black and white darkroom allows for much wider experimentation and easier special effects, so it is in the digital realm.

Conversion processes

The most common, and easiest, way to remove the colour from a shot is to choose the 'convert to greyscale' option in your image-editing application. This will produce a result similar to that you would get from using your camera in black and white mode. It's perfectly acceptable, and with a little adjustment to the brightness and contrast you can get some great results. Some of the more advanced alternatives (such as channel mixing) are beyond the scope of this book, but if your image-editing application supports it, it is worth finding out whether it offers the option to split a colour image into its individual channels.

▼ **A colour image is made up of three colour channels: red (top right), green (bottom right) and blue (bottom left). Each has a different tonal quality, with Red producing the darkest sky and best cloud detail.**

▲ **Even the most unpromising and unflattering original colour snap can produce a cool portrait, here by converting to black and white, painting away the background with black paint and increasing contrast.**

All digital camera photos are made up of three channels: red, green and blue, which mix together to see all the colours you see in the image.

Each of these channels is a greyscale (black and white) image, and each is very different. Using the channels on their own is very much like shooting in black and white (using film) with a colour filter on the lens; something that's long been done to emphasize cloud detail or foliage, or to produce better skin tones. The red channel is the best for getting great skies on sunny days, but it is worth looking at all three and seeing which result you prefer.

Applications such as Photoshop and Paint Shop Pro offer the option to split a colour image into its component channels, as well as advanced tools for dodging and burning (selectively lightening and darkening areas of the frame).

▶ **You can increase contrast a lot more in black and white than you can in colour, producing images with real impact.**

QUICK TIPS 📷

✔ Black and white is a lot more forgiving than colour, and can be a quick way to get over white balance, exposure and even sharpness problems.

✔ Always save a copy, so your original image is safe.

number 92
CREATE A HOCKNEY JOINER

Try this eye-catching twist on the panoramic shot, inspired by David Hockney's photographic work.

WHAT YOU NEED ✔

Software
Any image-editing software that offers basic photomontage or collage tools

●●✔●● **Moderately easy**
Some experience required

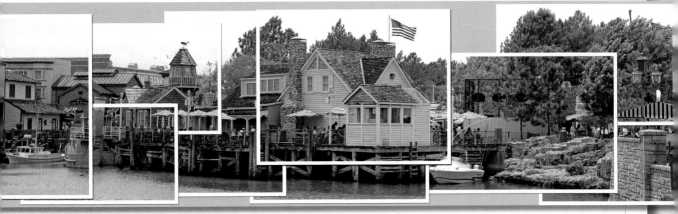

Taking its name from the famous British pop artist David Hockney, the joiner that bears his name is a great way to get a semi-abstract panoramic image. If you don't want the photorealism of a true panorama or you find that your digital images don't stitch together to form an authentic panorama, this could be for you.

In a Hockney joiner, a view wider than you could shoot with the standard lens on your camera is produced by shooting photos of overlapping parts of a scene. Then, when printed, the individual photos are overlapped to produce a view similar to the original scene but very obviously made up of multiple photos.

Look closely at the example here and you will see that the photos don't quite match up perfectly. This is quite normal; the lens in your digital camera does tend to introduce a very modest amount

of distortion that is normally not visible. When adjacent shots are linked, conflicting distortions become more obvious. Hockney used this – and the uneven exposure of contemporary cameras – to his advantage. Remember, we are not aiming to produce a photorealistic effect

here (that quality is reserved for the true panorama) but a collage.

QUICK TIPS 📷

✔ Joiners needn't just be used to produce wide views. Extra-tall, or tall and wide shots are also possible and can create some intriguing effects.

✔ Border or borderless? Prints produced with borders (as here) and without result in different effects. Prints with borders tend to hide distortions better than borderless ones and so should be used where distortions are too obvious.

🔍 ALSO SEE...

■ Shoot a panorama - p.104

GIVE YOUR SHOTS A WARM-UP

number **93**

A quick change to the tint in a picture can change a cold, clinical-looking photo into something much warmer.

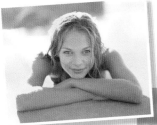

◀ **Portraits taken in shadow, even bright shadow as here, tend to look cold. A mild amount of warming using a warm-up filter (81) on the camera or the digital equivalent brings about a complete transformation.**

▲ **Morning mists are normally warm, bathed in the light of dawn. But in a very clear sky, even the first rays can be cold and blue. A stronger warm-up filter revises the scene, giving the impression of a much warmer sunrise.**

Sometimes photos tend to look cold, not because of the subjects but due to a blue colour cast. This is not flattering for portraits and gives landscapes an unappealing tint. You will often get this cold tint when your subjects are in shadow or if a landscape, say, is lit by a clear blue sky rather than by direct sunlight.

So how do we overcome it? We could try fitting a filter over the camera's lens. There are several such filters, which have an orange/amber tint, available from photo stores, that offer different degrees of warming-up. Strong warm-up filters can be quite potent, so there's a risk that the camera's white balance may automatically compensate for much of the filter's effects.

To have better control of the amount of warming that you apply, it is better to add the warmth digitally, when you have downloaded the photos to your computer. You'll find a set of digital photographic filter effects that include warming filters. These are sometimes called warming filters, but are sometimes denoted

QUICK TIPS

✔ The photographic filters in your image editor also offer equivalent cool-down filters that can neutralize overly warm images to give a more neutral result. You can use these to neutralize an incorrect colour cast produced when your camera's white balance is set to daylight and you've shot some photos under standard tungsten light bulbs indoors.

by the numbers 81 and 85, which correspond to the numbers of the filters once produced by Kodak that these digital filters emulate.

Unlike a filter placed over the camera lens, these filters won't be neutralized by the camera's white balance and you can also alter the strength to give the exact amount of warming that you require. Choose from a subtle neutralization of the cold colour tint through to a strong, and very obvious, amber glow.

GIVE A PHOTO A NOSTALGIC LOOK

number 94

Have you ever wanted to make your contemporary photos look as if they were shot by your Victorian forebears? If so, here's a simple way to get that aged look.

WHAT YOU NEED

Software
Any image-editing application with a colourize or sepia tone option, such as Elements

Moderately easy
Only three or four steps needed

Old photos – by which I'm talking of those shot in the Victorian and Edwardian eras – tend to take on an amber tone, thanks to chemical action over the years.

Many photographers, in the present day, tint their photos to make them look old. With our digital photos we too can give our images a look of yesteryear.

The process is often called sepia-toning because we are producing sepia and white prints from conventional black and white photos.

[STEP 1]

Choose the right photos. If you want an aged look, you will need photos of old subjects, or in the case of portraits, people dressed in vintage clothing. Modern scenes, or scenes with contemporary elements, just don't work. Here we have chosen this classic building for the treatment. It doesn't have to be black and white – we will attend to the colour later.

[STEP 2]

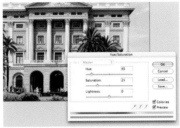

Load the image into your favourite image editor and open the Hue/Saturation dialog box. This is normally found under the Image menu. Click on the Colorize box. This (despite the name) removes the colour and leaves it as a monochrome photo – often salmon pink.

[STEP 3]

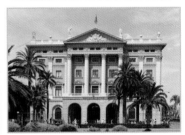

Move the Hue slider until you get a sepia colour. There is no right and wrong to the coloration – choose a tone that looks right and gives the aged effect. You can also adjust the saturation slider to change the intensity of the colour. Some photos will look good with subtle coloration, others with a bolder effect.

◀ If you want to make the effect look even more authentic, try applying a Grain or Noise filter to. This gives the appearance of film grain, which tended to be stronger on old photos. For a final flourish, use the eraser tool to soften the print's edges. Who would now argue that this photo was taken in 2006 rather than 1865?

QUICK TIPS

✔ Use your image-editing tools to remove features such as streetlamps and road signage that would otherwise betray the date of the photo.

✔ Experiment with other tones. Create moody landscapes, for example, with a blue tone.

number 95

CREATE A SIMPLE MONTAGE

Ever thought some of your photos were missing something? Master your image-editing software and you can start adding new elements to existing images for added impact.

WHAT YOU NEED ✓

Software
Any image-editing application with basic montaging tools (i.e. Photoshop Elements)

●●✔●● **Moderately easy**
Some experience required

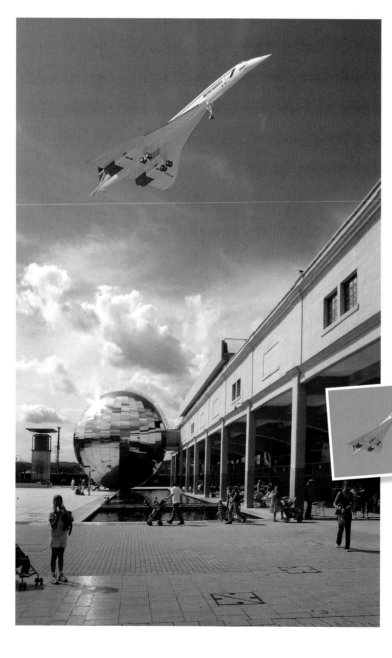

One of the most powerful aspects of image-editing software is the ability to manipulate the image to remove unwanted elements and distractions. Another is the opportunity to combine elements from one image with another. In image-editing terms, this is called montage and it is a very useful skill to master.

Here we use montage techniques to add a new element to an image. To make the process even simpler, we'll make a careful choice of the new element and also of the scene. So, for this combination we'll use an image of Concorde and combine it with a cityscape to give the impression of the plane soaring over the city. The careful choice? The sky in both images is clear blue; this will make the transposition less problematic.

[STEP 1]

Open both images in your image-editing software and make the Concorde image active. Select the plane itself. You could use the Lasso tool if you have a steady hand to draw around the edge of the plane or, better still, the Magnetic Lasso. This draws a selection by snapping to any sharp edges it finds – in our case, the outline of the aircraft.

[STEP 2]

To place the selected aircraft in the cityscape, copy the selection (using the Copy command in the Edit menu) to the new image. Paste the selection into place. Because we began with two separate images, the scale of each may be different and the resulting transposed image may not match the scale of our intended recipient.

[STEP 3]

Make the aircraft the right size by using the Transform or Transform Selection command, also usually found in the Edit menu. Change the scale until it becomes something appropriate. In situations such as this there is no right and wrong, but you do need to produce a result that looks as though it might have been taken for real.

[STEP 4]

Make any final adjustments. Position the aircraft so that the perspective looks right. Sometimes it's easier to leave the image for a few minutes and then return; any glaring perspective errors become more obvious. When you are happy, save your image.

QUICK TIPS

✔ When you create an image made up of elements from different sources, save the image file in a format that preserves these layers. This is essential if you want to open the image later and reposition or rescale the elements. In Photoshop Elements the Photoshop PSD and TIFF formats (among others) will preserve layers.

✔ Check the lighting in montages to ensure that shadows, for example, all fall broadly in the same direction. Here, the light falling on the buildings of the cityscape and the light on Concorde all appears to come from the same direction, enhancing realism.

✔ The more you practise, the better you'll get at montage.

🔍 ALSO SEE...

■ Add a sunset to any photo – p.142
■ Try your hand at masking – p.150
■ Create an arty optical illusion – p.154

ADD A SUNSET TO ANY PHOTO

number 96

Ever wished you'd been around at the end of the day to shoot a scene with the sun setting? Here's how you do it digitally – without all that waiting around.

WHAT YOU NEED

Software
This step-by-step uses Adobe Photoshop, but most similar applications have the same tools

●●●●◐ **Advanced**
Image-editing experience required

[STEP 1]

Start by opening the image you want to add the sunset to. Since the main subject of the final picture will be a silhouette, you need to choose pictures with strong, recognizable shapes. This shot, of the ancient monoliths of Stonehenge in southwest England, is ideal.

[STEP 2]

We need to make some space for the new sky by increasing the vertical canvas size (Image > Canvas Size). I've roughly doubled it in this instance. Set the anchor (where the original picture will sit on the new canvas) to the bottom centre.

[STEP 3]

Now you need to get rid of the original sky. To do this, you need to select the sky in its entirety. How you do this will depend on the nature of the sky. As this one is pretty featureless, we can either use the Magic Wand and the Shift key to add areas, or – as here – use Photoshop's Color Range command (Select > Color Range). Click in the sky area and increase the fuzziness until the whole sky is selected.

[STEP 4]

Double-click on the Background layer (it should be the only one in the Layers palette) to promote it to a normal editable layer. With the selection made in step 3 still active, hold down the Alt key and click on the Add Layer Mask icon at the bottom of the Layers palette. Holding down the Alt key creates a mask that hides the selection (clicking the icon alone creates a 'reveal selection' mask).

[STEP 5]

Click on the Layer Mask thumbnail (circled here) and zoom in to the image to clean up the cutout created by the mask. Remember, black paint extends the mask (and hides more of the image), whereas white paint reveals more of the image.

[STEP 6]

I don't want to make a completely black silhouette – I want some of the shape and texture of the stones to be visible. I'm going to use Hue/Saturation controls to do this, via an adjustment layer (so I can go back later and tweak the settings). Choose Layer > New Adjustment Layer > Hue/ Saturation. When the new layer dialog appears, tick the Group with Previous Layer option. This will restrict the colour changes to the visible pixels in this layer, not those in the new sky we're about to drop in below it.

[STEP 7]

Click on the Colourize button and move the hue to around 29, which is a warm sunset colour. Reduce the saturation to around 30 and the lightness to somewhere between -60 and -70.

[STEP 8]

Finally, open your sunset image and use the Move tool to drag it onto your picture. Move it to the bottom of the layer stack in the Layers palette and resize it to fit using the Edit > Free Transform command. The end result is shown to the right.

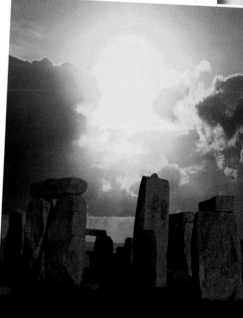

96 MORE SUNSET IDEAS

A THREE-LAYER SANDWICH

This image was created in a couple of minutes in Photoshop. First the New York shot was masked using the Magic Wand to select the sky. The sunset shot was brought in as a new layer and its saturation boosted. Finally, a 'normal' cloudy sky image was toned orange using Hue/ Saturation (set to Colorize mode) and placed at the bottom of the layer stack. The middle layer (the sunset) was set to Hard Light. The two sky layers combine in the final image to add texture.

Image contrast increased and sky masked off.

Sunset layer set to Hard Light.

Cloudy sky layer toned and placed at bottom of stack.

▲ The original sunset image – used on the previous pages. Note that I played with the levels and boosted the colour for the montages.

▲ Simply changing the colour of the bottom (cloudy sky) layer to blue makes a dramatic difference to the picture.

▼ In this case, the silhouette was made totally black using the threshold adjustment in Photoshop Elements (after the image had been cut out), and the bird added from another image.

CLEAN UP WITH CLONING

number 97

From skin blemishes to cars or telegraph poles blighting a landscape, there are lots of things we'd like to take out of our pictures - and it's surprisingly easy in the digital darkroom.

WHAT YOU NEED

Software
Any image-editing application with a clone or rubber stamp tool

●●✔●● **Moderately easy**
The basic technique is very simple, but it takes practice to get it right

#096–097

In the old days, if something was in a picture when you took it, you were stuck with it. In the digital era, you can seamlessley remove anything, from a pimple to an elephant, from a scene, using the tools provided in even the most basic image-editing application. Here's a quick step-by-step showing how easy it is to 'clone' one area of an image onto another area.

[STEP 1]

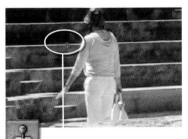

Open the image in your image-editing application and choose the clone or rubber stamp tool. Zoom in on the area you want to work on. Hold down the Alt key and click in the area you want to clone from (i.e. the pixels you are going to use to 'paint' over the area you want to remove).

[STEP 2]

Let go of the Alt key and start to paint over the area you want to remove. If it doesn't line up properly, just undo and try again (with subjects such as this, getting it right is a bit hit and miss). The clone tool will paint with pixels taken from the area you alt-clicked on in step 1.

[STEP 3]

You'll need to change the 'clone from' point every now and again (i.e. alt-click somewhere else) or you'll end up with a repeating pattern. Use a smaller brush for more fiddly areas and to clean up the end result. Look for any obvious joins or repeating textures and clone over them, and you're done!

number 98 TURN A DAY PHOTO INTO NIGHT

Too busy at home to get out to shoot landscapes by night? Here's how to turn day into night using layer blending options and adjustment layers.

ADVANCED TECHNIQUES !

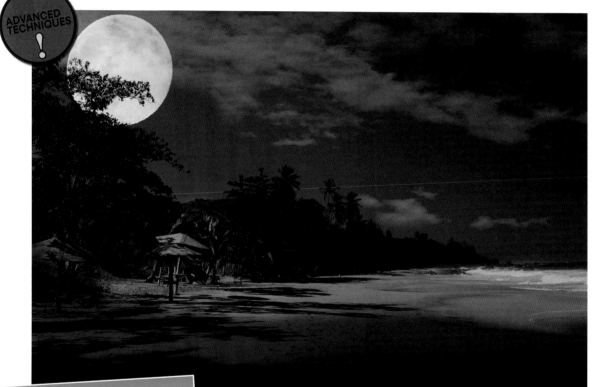

▲ The start image, which was shot in the middle of a sunny day on the island of Tobago.

[STEP 1]

We'll start with the overall tone of the picture. Night scenes tend to have very little colour, and a strong blue cast. Choose Layer > New Adjustment Layer > Hue/ Saturation. Click on OK when the new layer dialog appears and try the following settings in the Hue/Saturation dialog (with the Colorize option ticked); Hue 230, Saturation 35, Lightness –40. Experiment until you get the right mood, then click OK.

#098

[STEP 2]

Now to add the moon. If you don't have one in your own collection, you'll find lots on the

Internet (www.nasa.gov is a good place to start). Drag it onto your main image using the Move tool – it will appear as a new layer.

[STEP 3]

We could select and delete the sky part of the moon layer, but I've chosen to take advantage of the fact it is totally black and use the Layer Blending options. Double-click on the new (moon) layer and when the Layer Style window appears, you will see the Blending Options pane appear. Move the shadow slider on the 'This Layer' scale a little to the right, as shown above. You will see the black part of the layer disappear.

[STEP 4]

Select the Background layer and choose the Burn tool from the toolbar. In the Options bar, choose a large soft brush and set the range to Shadows. Use sweeping strokes to darken the top and bottom of the image.

QUICK TIPS 📷

✔ If your image-editing application does not offer layer blending options (or 'blend if ranges'), you'll need to adapt this workshop. For step 3 (removing the surround from the moon), simply change the moon's layer Blend Mode to Screen. To get the moon behind the tree (step 4) is more tricky – you'll just have to mask or erase the area where the tree goes in front of the moon.

✔ In this step-by-step, I've used Adjustment Layers (found in applications such as Photoshop, Elements and Paint Shop Pro) to apply Hue/Saturation changes. This is simply because it allows us to go back and change settings later. You can get the same result just by applying the Hue/Saturation changes directly to the layer.

[STEP 5]

Finally, if you want to add some subtle cloud detail, you can. Add a sky from another image as a new layer and increase the contrast using levels so the blue sky goes as near to black as you can get it. You should be able to get the clouds to overlay your image using the same method described in step 3. Give it a try!

[STEP 6]

This is the end result after flattening the layers and tweaking the contrast using Curves and the colour using Hue/Saturation again.

number 99 TRY AN ADVANCED PHOTOSHOP SKETCH TECHNIQUE

ADVANCED TECHNIQUES !

Use Photoshop to create a realistic hand-drawn effect.

WHAT YOU NEED ✔

Software
This step-by-step requires Adobe Photoshop 6.0 or later

●●●●●◐ **Advanced**
Image-editing experience required

Photoshop is not the most well-equipped application when it comes to 'natural media' filters such as paint effects. But there is one tool that can be used to produce pretty impressive effects with a little practice and the right settings: the Art History Brush.

[STEP 1]

Start by opening your image in Photoshop. Use Curves or Levels to boost the contrast. Don't worry about colour – we're not going to see any of it in the final result.

[STEP 2]

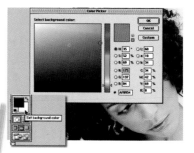

Select a new background colour by clicking on its swatch at the bottom of the toolbar. When the Colour picker appears, choose a sepia tone – I'm using R175, G137, B84.

[STEP 3]

Click on OK to accept the new background colour. Choose Edit > Select All and press Ctrl-Delete. This will fill the entire canvas with the background colour.

[STEP 4]

Open the History palette (if it is not already open) and set the source for the History Brush by clicking to the left of the Select Canvas step.

[STEP 5]

Select the Art History Brush – hold down the Alt key and click on the History Brush. The tools icon is a brush with a curly line. You now need to make some changes to the tool options using the bar at the top of the page. Set the Brush size to about five pixels, Mode to Luminosity (so we paint only with light and dark, not colour) and opacity to around 10-15%. For the style use Tight Long and for the Area try around 200-400 pixels (it needs to be around one-fifth the width of your image in pixels). Leave the Tolerance set to 0% (in Photoshop 6.0 leave spacing set to 0% and Fidelity to 100%). Note that the Brush size defines the size of the individual strokes, while the Area defines how many strokes are laid down – and over what area – as you paint.

QUICK TIPS

✔ Use a smaller brush (down to one pixel on small images) and a high opacity for the most detailed areas – eyes and so on.

✔ Use the square bracket keys to vary the brush size

and the numerical keys (0-9) to vary the opacity (press 2 for 20% and so on).

✔ The brush works better, and is easier to control, on lower-resolution images.

[STEP 6]

Start by quickly painting around the canvas to roughly establish the outline of your subject. Don't go right to the edges and don't lay down too many strokes – it is easy to overdo this effect at any stage!

[STEP 7]

Now experiment with different brush sizes (smaller for more detailed areas, larger for a smudgy look), different Area settings and different Opacities to paint in the face. Use the History palette to go back if you mess things up too much.

[STEP 8]

Finally, when you are totally happy with the result (remember, it's easy to go too far!), run the Texturizer filter (Filter> Texture> Texturizer). Use the Canvas texture, with a Light Direction Top Left or Top Right. Tweak the Scaling and Relief settings to suit your taste.

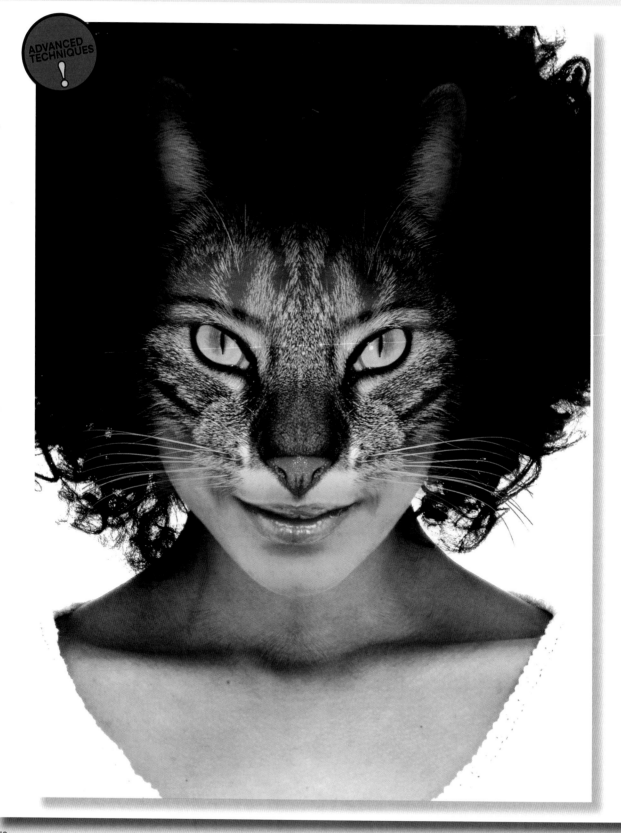

number 100 TRY YOUR HAND AT MASKING

Melding two images together in a montage is one of the most common digital imaging tasks, and one of the most difficult to do convincingly. Here's a quick walk-through.

WHAT YOU NEED

Software
This step-by-step uses Adobe Photoshop, but can be adapted to other image-editing applications

●●●●● **Advanced**
Image editing experience required

This project uses two images to make a single composite – a woman with a cat's face – using a greyscale mask. Whether this type of 'fantasy' image is to your taste or not, by following the steps you'll learn how to create and use masks for montage. You'll need to find your own starting pictures – I'm presuming you are using something similar to the two shots here in this step-by-step. Incidentally, if you have a pair of good symmetrical face-on shots (the human and the cat), you can miss out the first few steps.

[STEP 1]

Start by opening an image of an animal's face and rotating it if necessary (as here) to make the face the right way round. Increase the Canvas size by around 10cm (Image > Canvas Size). Set the Anchor to the middle left square. You should now have some more room on the right-hand side of the image.

[STEP 2]

Use the Polygonal Lasso tool to draw a four-sided selection covering the left-hand side of the cat's face, with one of the lines cutting straight up the middle (as shown here). Next we need to create a new layer in the image containing a copy of the area we just selected (Press Ctrl-J).

[STEP 3]

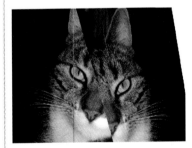

I now need to flip and rotate the new layer to make the other half of the cat's face (we're doing this because I couldn't find a face-on picture of a cat – but it's good practice and creates a symmetrical result). Use Edit > Transform > Flip Horizontal then Edit > Transform > Rotate. In each case, press Enter to confirm the transformations.

[STEP 4]

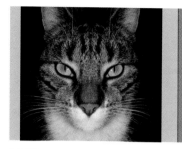

You now need to flatten the image, then straighten up the cat and crop out the rest of the image. You can do this in one step using the Crop tool, which allows the cropped area to be rotated.

[STEP 5]

Without closing the cat image, open your other image (the person). To place the cat image into the woman image as a new layer, drag the cat onto the woman using the Move tool (press V for the Move tool).

[STEP 6]

You now need to scale the cat layer to fit - the best way to do this is to get the eyes to match. Temporarily reduce the opacity of the cat layer (so you can see through it) using the slider on the Layers palette. Now choose Edit > Transform > Scale and drag the corner handles to resize the cat layer.

[STEP 7]

Now cut out the cat's face. Try using the Color Range tool (Select > Color Range) to select all the black areas at once. Don't worry if your selection is messy - it is only a starting point.

[STEP 8]

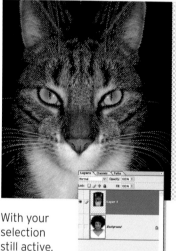

With your selection still active, hold down the Alt key (this changes the mask to Hide Selection) and click on the Add Layer Mask icon at the bottom of the Layers palette (see above).

[STEP 9]

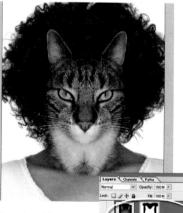

You should see something like this - a rough cutout based on the selection you made in step 7. You'll also see that a layer mask icon has appeared in the Layers palette next to the cat thumbnail. The layer mask hides any areas that are black, and shows any areas that are white.

#100

[STEP 10]

We can now edit the layer mask to fine-tune the areas of the cat layer that we hide. Select the Paintbrush tool and choose a fairly large soft-edged brush. Click on the layer mask icon in the Layers palette (as circled above) and try painting on it. If you use black paint you'll hide more of the cat layer; if you use white paint you'll reveal more. The beauty of a layer mask (as opposed to simply using an eraser) is that the pixels are never actually removed; they're just hidden. So if you make a mistake you can just swap paint colour and correct it.

[STEP 11]

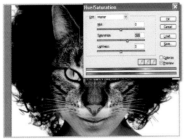

When you are happy with the mask, take a look at the colour match between the two parts of the composite. Adjust the colour and contrast of each layer until they are as close as possible – here I'm increasing the saturation of the cat layer to give it more punch. I also selected the cat's eyes and boosted the yellow.

[STEP 12]

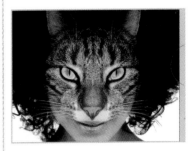

Finally, fine-tune the mask using pale grey paint to produce semi-transparent areas where some of the skin tone can show through. You may also want to reduce the opacity of the cat's eyes to let the human eyes show through. In this case, I also reduced the opacity of the upper (cat) layer by a few per cent.

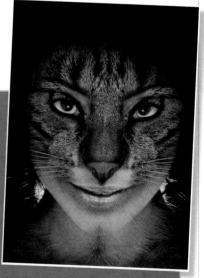

▲ This image was produced without using a mask at all – the cat was placed onto the woman as a new layer and resized to fit. I then changed the blend mode of the cat layer to Multiply and cropped the image quite tightly. The result is a very furry woman!

TRY THIS

Copying the cat layer onto a different picture and adjusting the mask produced a very different image. I used the Liquify tool (found in Photoshop and Elements) and Warp Brush (found in PSP) to drag out the model's teeth to make fangs.

number 101 CREATE AN ARTY OPTICAL ILLUSION

Let's use our Photoshop skills to produce a version of M. C. Escher's 1948 classic image of drawing hands. This step-by-step will also work with Photoshop Elements.

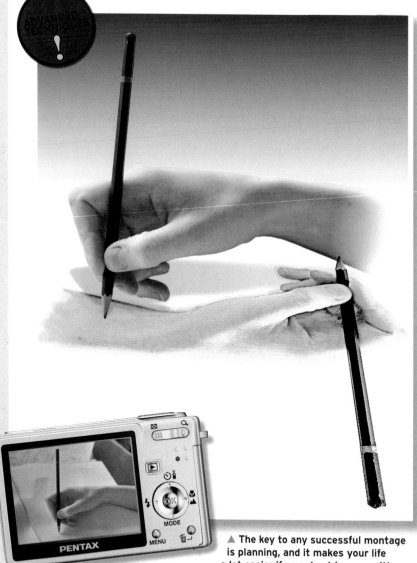

ADVANCED TECHNIQUES !

▲ The key to any successful montage is planning, and it makes your life a lot easier if you shoot images with a specific project in mind. This is what I did here, taking a single shot of a hand holding a pencil in order to recreate - in 21st-century style - M. C. Escher's famous 'hand drawing a hand drawing a hand' picture.

[STEP 1]

Start by opening the hand picture you've taken. At this point, we need to convert the background layer into a standard editable layer; double-click on the background thumbnail and click on OK when the New Layer dialog appears.

[STEP 2]

Duplicate the background layer by pressing Ctrl-J. Select the Magnetic Lasso tool and trace around the entire hand and pencil.

[STEP 3]

Once the selection is complete, add a layer mask (Layer > Add Layer Mask > Reveal Selection) or click on the Add Layer Mask icon at the bottom of the Layers palette. Hide the bottom layer by clicking on the little eye icon.

[STEP 4]

Now we need to clean up the selection to make sure we don't have any stray pixels or jagged edges left. Zoom in to 100 per cent, select the Paintbrush tool and click on the Layer Mask thumbnail to make sure you're painting on the mask, not the layer itself.

[STEP 5]

Use black paint on the mask to hide more of the layer, or white paint to reveal more. Go around the entire hand to make sure the edge is as clean and accurate as possible.

[STEP 6]

If at any point you're not sure whether the mask fits the outline of the hand perfectly, simply 'unhide' the underlying layer for a moment to see the entire picture unmasked. Hide it again to continue editing the mask.

[STEP 7]

 We want the arm to fade out at the edge, so there's a little more work to do on the mask yet. Set the foreground colour to black, and, making sure you're still working on the layer mask, select the Gradient tool. From the drop-down menu in the options bar, choose Foreground to Transparent.

[STEP 8]

Still working on the mask, click on the edge of the frame near the middle of the arm and drag to about half-way to the wrist (as shown above).

[STEP 9]

You should see the image change as shown above. Now our mask is right, we need to add the same mask to the other (lower) layer. Start by right-clicking on the mask thumbnail and choosing the first option in the drop-down menu; Set Selection to Layer Mask.

[STEP 10]

Now click on the lower layer's thumbnail and add a layer mask (Layer > Add Layer Mask > Reveal Selection).

[STEP 11]

Rotate the lower layer by 180° (Edit > Transform > Rotate 180°).

[STEP 12]

Increase the Canvas size (Image > Canvas Size) to about double its current height and a few centimetres wider.

[STEP 13]

Use the Move tool (press V) to position each layer as shown above.

[STEP 14]

Duplicate the lower layer (the upside-down one) and add a new layer, filled with white, to the bottom of the stack.

[STEP 15]

Duplicate the lower layer (the upside-down one) and add a new layer, filled with white, to the bottom of the stack.

[STEP 16]

Increase the contrast of the grey hand slightly using Levels (Image > Adjustments > Levels). Move the black and white sliders towards the centre a little.

[STEP 17]

Choose Filter > Brush Strokes > Angles Strokes. Experiment with the settings or use mine: Direction Balance 35, Stroke Length 10, Sharpness 5.

[STEP 18]

Now choose Filter > Sharpen > Unsharp Mask and set the Amount to around 140, the Radius about 7 and the Threshold to 0. Click OK.

[STEP 19]

Duplicate the layer containing the greyscale hand and set the blend mode of the upper copy to Screen. Choose Layer > Merge Down (or press Ctrl-E) and click on the Preserve option in the dialog that appears.

QUICK TIPS

✔ If you want to check the accuracy of your mask, add a layer directly underneath and fill it with black. Any stray pixels will now show up in sharp relief. Get the mask right and delete the black layer.

✔ This tutorial will also work with Photoshop Elements, though you'll need to delete pixels rather than use masks.

[STEP 20]

Select the Paintbrush tool and choose the brush 'Spatter 39 pixels'. Click on the layer mask for the grey hand and paint with grey paint to give the soft edge a more 'drawn' look.

[STEP 21]

Tweak the brightness and contrast of the 'drawn' hand layer if necessary, then choose Filter > Texture > Texturizer. Use the Burlap texture and set the Scaling to 81%, Relief to 2 and Light Direction to Top.

[STEP 22]

Use the Gradient tool to add a gradient to the bottom (white) layer. You can use any colour you wish, or change it later using the Colorize option in Image > Adjustments > Hue/Saturation.

[STEP 23]

Finally we are going to add a shadow to the upper hand. Duplicate this layer (click on it in the Layers palette and press Ctrl-J) and drag the lower version's Layer Mask to the trash icon on the Layer palette. Click on 'Apply' when the dialog shown above appears.

[STEP 24]

Temporarily hide the upper (copy) layer with the full-colour hand. Making sure the lower of the two colour hand layers is selected, choose Image > Adjustments > Threshold and move the slider all the way to the right to get a silhouette.

[STEP 25]

Choose Edit > Transform > Scale and click on the anchor in the middle of the top of the bounding box that appears around the layer and drag down to squash the shadow. Change the opacity of this layer to around 40-45%.

[STEP 26]

Your selection should now look like this, although the actual selection is a gradient. Choose Filter > Blur > Gaussian Blur and use a smallish radius of around 5 pixels. You should see the shadow gets more blurry from left to right. Deselect (Select > Deselect) and add a layer mask to the shadow layer.

[STEP 27]

Enter Quick Mask Mode (press Q) and select the Gradient tool. Create a black to white gradient from the bottom left to the top right of the frame. The quick mask should look something like the one shown above. Exit Quick Mask Mode (press Q again) to turn your mask into a normal selection.

[STEP 28]

Draw a gradient (using the Gradient tool, obviously!) onto the layer mask for the shadow layer, from black to white, from right to left. You may need to try a few times to get exactly the right 'fade away' for the shadow.

FINISHING TOUCHES

OVERLAPPING AREAS

Zoom in and closely examine your finished image. If, as here, there is overlap where you can see the 'hand drawn' hands, edit the mask for the colour hand layer to reveal the tip of the pencil.

ADDING COLOUR

To make the 'hand drawn' version of the hand look like colour pencil, unhide the original, untouched upside-down hand, move it to above the greyscale version and change the blend mode of the layer to Color.

PERSPECTIVE

For my final image, I decided to alter the perspective of the 'drawn' hand to make it look like it was on paper. Use Edit > Free Transform to stretch each corner.

INDEX